Contents

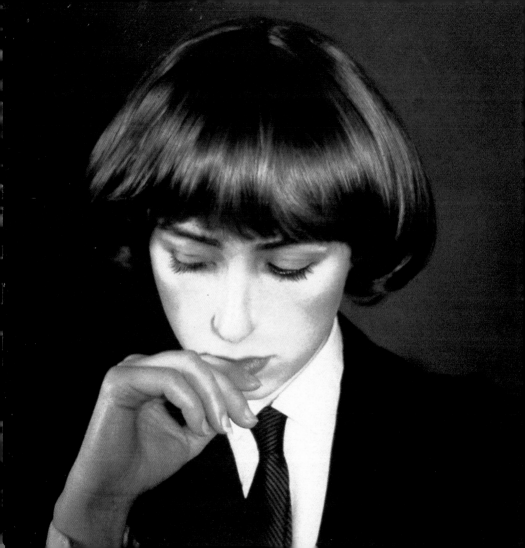

The Essential Cindy Sherman

It's not the photographs that got small. It's Cindy Sherman that got big. And with her, all of photography—which has experienced a giant surge in popularity since the 1980s. Prices have gone out the roof and gallery exhibitions proliferate. When the Cindy Sherman photograph *The Hitchhiker*, which sold in 1979 for $50, was resold at the Christie's 1999 auction for $200,000, people wondered what was going on. Why the dramatic appreciation? And wherein lies the value of a black-and-white photograph?

If you're new to the work of Cindy Sherman, you're in for a treat. Think back to the last time you were repulsed by an image but could not keep your eyes off it—and actually laughed at it, hoping no one would notice. Ever happen? It will now.

The wildly talented Sherman—creator of pictures that haunt and arouse—produces often bizarre, sometimes graphically unpleasant images that can disturb yet beguile at the same moment. Though for many people Sherman is not a household name, she is famous among art lovers who track the world of photography. Despite her young age, she is acknowledged as one of her generation's most gifted and influential talents. Each year her work attracts larger, more diverse crowds, and if you go to an exhibition of Cindy Sherman photographs, you'll see that the crowds are part of the fun.

ABOVE
Untitled #283B
1980
20 x 24"
(45 x 54 cm)

OPPOSITE
Untitled #283A
1980
20 x 24"
(45 x 54 cm)

There are Reasons for Everything

How did Cindy Sherman happen? To set the stage, recall for a moment the exuberant 1980s, a time when the New York art world exploded with a new generation of artists. Suddenly art patrons were everywhere. **Keith Haring** (1958–1990) and **Jean-Michel Basquiat** (1960–1988) took graffiti art from the subway tunnels to the art galleries of Madison Avenue. **Julian Schnabel** (b. 1951) assembled heroic canvases of mixed-media crockery. **Robert Longo** (b. 1953) mined the sci-fi expressionism of Fritz Lang's *Metropolis* and the moody chic of advertising layouts in his creation of epic paintings. **David Salle** (b. 1952) transformed the media saturation of modern life into canvases that merged drawing, photocopying, and oils. Pop prince would-bes **Jeff Koons** (b. 1955) and **Mark Kostabi** (b. 1960) publicly struggled to become the next **Andy Warhol** (who wasn't even dead yet). As if this weren't enough, newly rich stockbroker whiz-kids (the real-life role models for Tom Wolfe's novel *Bonfire of the Vanities* and Oliver Stone's movie *Wall Street*) frantically bid against each other to acquire the hottest and hippest new investment portfolio: the works of these young artists.

Cookin' in The Kitchen

In 1980, a different kind of explosion was taking place at one of the cradles of the late-20th-century avant-garde. The Kitchen, an alternative space that normally showcased the work of performance artists

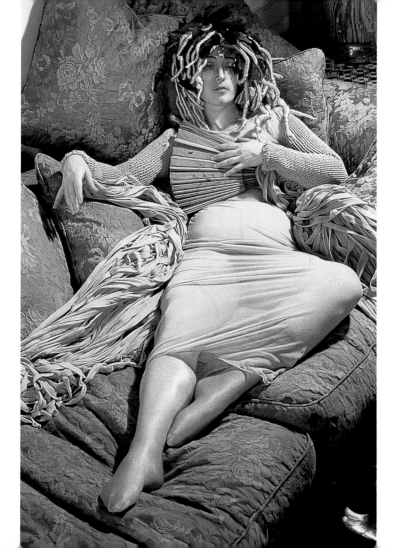

such as **Laurie Anderson,** was instead hosting a photography exhibit, *Untitled Film Stills,* by the more-or-less unknown photographer Cindy Sherman. The response from her peers was resoundingly positive, and as a wider audience became acquainted with her work, people wondered if these film stills were taken from *real* movies—and if so, what could they possibly be about? Who was the "actress" in the photographs? And where did this quirky oeuvre come from?

The ensemble of these richly provocative *Untitled Film Stills* reminded viewers of stills from movies by directors John Ford, Roberto Rossellini, Jean Renoir, and Roger Vadim, which featured women starring in roles that seemed familiar, but not *that* familiar. There was curiosity about the content and origin of the pictures, but obviously there was no explanation from either the artist or the gallery. So the spectators wandered about, inventing plots, assembling various frames, and later telling friends about this amazing new show, so different from anything they had seen before.

A Star is born

The creator of these powerful images grew from an inconspicuous Long Island childhood to become one of "The 20th Century's 25 Most Influential Artists" (*ARTnews*, May 1999). Though the 15 years between Sherman's spellbinding show at The Kitchen and 1995 was an era of profound change in the art world—Haring had died of AIDS,

Sound Byte:
"I wonder how it is that I'm fooling so many people. I'm doing one of the most stupid things in the world…and people seem to be falling for it."
—CINDY SHERMAN, 1982

Basquiat from drugs, and Warhol from medical malpractice; Longo had gone off to make movies; and Schnabel, in the eyes of many, had ceased to create much of interest—they were good years for the artist of that Kitchen show, who would receive a MacArthur Foundation "genius" grant and sell her *Untitled Film Stills* to The Museum of Modern Art in New York for more than $1 million. It was obvious to many that a new star had been born and that the way people viewed photography had changed forever.

Just the Pix, Ma'am

How did Cindy Sherman succeed in transforming photographs of her-self into *the* defining images of our image-drenched age? How did this quiet girl from the suburbs of Long Island rock the world of popular culture as no other artist had since Andy Warhol? This photographer, who has appeared in rock lyrics and whose exhibition of *Untitled Film Stills* at New York's Museum of Modern Art was underwritten by Madonna, jarred the art world by transforming simple childhood games—dressing up, playing with dolls, assuming roles—into a photo-graphic exploration that gave voice to the creative issues of our time, all the while providing the romp of a good old-fashioned horror movie.

I am not a Photographer

Think about how pervasive photography has become within pop cul-ture. From current events to tabloid gossip, from *The World's Funniest Home Videos* to cherished family snapshots, **we use photographs to document our lives**. It's almost as if we don't believe something is real unless we see a picture or video of it. The corollary is true, too: When we do see something on television or in the media, it often *becomes* real to us, even if it's fiction. Why do we search for truth in photographs? Why do we want to believe that photos are mirrors of reality? What is it, in fact, that we want to believe? These are some of the questions that fascinate Cindy Sherman and that she explores in her work.

OPPOSITE
Untitled #103
1982. 30 x 19 ³/₄"
(67.50 x 44.44 cm)

Here is an artist who uses photography, but who doesn't consider herself a photographer. She takes pictures in which she appears as a model, but insists that the work has nothing to do with *her*. She calls into question accepted notions of femininity, but claims she is not making work as a feminist statement. She makes up stories without beginnings or endings, leaving the narrative to the imagination of the viewer. How does Sherman reconcile these apparent contradictions? In fact, she does not, and paradox is the core of what makes her work so irresistible.

Sound Byte:
"The only reason I don't call myself a photographer is that I don't think other people who consider themselves photographers would think I'm one of them."
—CINDY SHERMAN, 1996

The Sex Pictures do not deliver actual sex acts. Her Centerfolds series offers no nudity. There are no actual movies on which the *Untitled Film Stills* are based, so if you thought you could rent them, you're out of luck. Sherman doles out just enough information to *imply* something by setting up the "action," then hands the ball off to the viewer. You are the one who decides the meaning and importance of her photographs. Where you run with each image is your call. What's going on is simply what's in front of you, and the question remains: What do *you* see? And why do *you* see

that? Therein lies her significance as a late-20th-century artist: While her work may not be beautiful in the traditional sense, it captures the fancy of critics and Sherman fans alike. Why? Because her photographs are springboards that seduce us into contemplating our own emotions—not hers—and for that reason this book will focus more on the work of Cindy Sherman than on her personal life.

No Names, Sorta

While Sherman did indeed come up with the name *Untitled Film Stills*, neither she nor her gallery has named any of her other works. The titles or "series" names that you will hear—even when the individual works do not properly belong to a "series"—are generic in nature, assigned by art critics, and used to define a broad category of images made during a specific period of time. The following headings should help you grasp the scope and chronology of Sherman's work before we launch into it. Actual series names are italicized, whereas "groups" of photographs are not:

- Untitled A-E: 1975

- *Untitled Film Stills*: 1977–88

- Rear-Screen Projections: 1980–81

- Centerfolds: 1981

- Pink Robes (aka Red Robes): 1982

- Fashion: 1983, 1984, 1993, 1994

- Fairy Tales: 1985

- Disasters: 1986–89

- History Portraits: 1989–90 (and one image from 1988)

- Sex Pictures: 1992

- Horror and Surrealist Pictures: 1994–96

- *Office Killer*: 1997

- Black & White work from 1999

Portrait of a young Girl (who makes lots of Portraits of young Girls)

And so the story begins. It's the late 1960s and an unassuming teenage girl sits alone in front of the television, but her attention is not focused on *Laugh-In*. Instead, she is fixated on the miniature copies she has made of *all* her clothes while planning out her weekly school wardrobe—an early example of the focus and attention to detail that will support Cindy Sherman's later creative preoccupations. She brings a zeal and an intensity to this common effort that set her *way* apart from her peers.

OPPOSITE
*Untitled Film
Still #56*
1980
8 x 10"
(18 x 22.50 cm)

From New Jersey to Long Island

Sherman's parents, **Dorothy** and **Charles**, get married in the early 1930s, and over the course of the next decade they have four children—three boys and a girl. Their fifth and last child, Cindy, is born in Glen Ridge, New Jersey, on January 19, 1954. The 19-year span between the oldest and youngest Sherman children means that the first two kids are effectively out of the house by the time Cindy comes along.

Growing up as though she were an only child in the late 1950s and early 1960s, with parents who came of age during the Depression, Cindy would later acknowledge that she had been a loner all her life. Shortly after her third birthday, her engineer father gets a new job and moves the family to the bucolic Long Island town of Huntington Beach, on the north shore of Long Island Sound.

An hour east of Manhattan, Huntington Beach is a small, neighborly, bay-front community, with pretty houses and tidy yards. For Sherman, it is a nice place to grow up. In fact, it is the archetypal post–World War II suburban community, filled with single-family homes,

American-made cars, nuclear white families, good public schools, and, most important—by the late 1950s—*television*.

The TV Generation

Television becomes the background text and music of Sherman's adolescence (and, to a degree, of her adult life as well). She forms the habit of watching TV while doing something else at the same time, such as drawing, printing, and making things in the safety of her home. She watches everything—old movies, situation comedies, and cartoons—and will later be inspired by her fondness for such TV programs as the *Mary Tyler Moore Show* when creating the Rear-Screen Projection photographs. Like others of her generation, Cindy learns of the events of the day from television—the assassination of John F. Kennedy, the race riots that rock American cities in 1968, the Vietnam War, the first man landing on the moon, and the counterculture "happening" of Woodstock. Between the television shows and the TV broadcasts of movies, she also learns about the different roles and identities that our culture offers, especially to women. From early on, Sherman sees the world from the vantage point of a TV-saturated childhood, with clearly mandated (*not* womandated) social and sexual roles.

Snapshot of Cindy Sherman (left) and friend, Janet Zink, dressed up as old ladies, c. 1966

Who am I? Who do I want to be?

The young Sherman engages in games of make-believe, keeping a special trunk filled with clothes that she uses when playing dress-up. Like

What: A personal documentation project of the artist's childhood and adolescence that she calls *A Cindy Book*. (See samples from *A Cindy Book* on these pages.)

Partly by virtue of being mundane (Sherman's childhood is as uneventful as everyone else's), *A Cindy Book* is an engaging and highly entertaining scrapbook of family photographs that the artist mounts and scribbles on in the ways that all children see family portraits.

"That's me": You'll notice that she has circled herself in every photo and inscribed "That's me" next to it. But half the book wasn't completed until years later, when Sherman returned home from college one weekend and rediscovered the unfinished book. She vaguely remembers having worked on it during her preteen and teen years, and now, as a would-be artist, decides to complete it as a "piece." By playing once again with notions of time and social roles, she inscribes "That's me" next to the various photos of herself, but in handwriting that she alters to fit the age of the Cindy in each photo.

Why it's interesting: For starters, there are those 1970s hairdos. But there's also an eerie sense that the suburban-girl getups are simultaneously the "real" thing and character impersonations: baby on the beach with happy mom; teenager at the beach house with happy girlfriends; prom night; and the occasional presence of military types.

Her past: Sherman's sense of identity is not vested in the tokens of family history, but she knows that our rites of passage become the myths by which we identify ourselves in old photographs: What a popular girl! What a happy baby! —That's me! That's me, too!

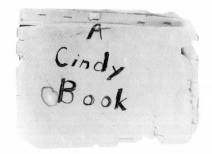

4 5

That's me,

Thats me,

6 7

Thats me, Thats me,

The United States withdraws from Vietnam in 1972, and a peace accord is signed in late January 1973 (though American planes continue to bomb Cambodia until August).

Five burglars are arrested at the Democratic Party's national headquarters at the Watergate Hotel in Washington, D.C., in June 1972. President Nixon keeps the case hushed up long enough to be overwhelmingly reelected to a second term as president in November 1972.

Glitter Rock emerges in the form of bands like the New York Dolls and Roxy Music. David Bowie's The Rise and Fall of Ziggy Stardust and the Spiders from Mars, which exemplifies the camp and glamour of the genre, is released in 1972.

The Godfather introduces a popular yet intelligent spin on gangster movies.

her school outfits, however, this is not the standard try-ing-to-look-like-a-grown-up-version-of-yourself-by-hobbling-around-in-mom's-best-shoes kind of play. Instead, she and her friends (and nieces and nephews, who are more like siblings) *transform* themselves into characters—like an old woman or a monster—since this is "more fun than just looking like Barbie." She invents characters and puts them together in various forms of masquerade. "I'd dress up like an old woman and walk around, fooling the neighbors. Things like that."

Normalcy breeds Normalcy (well, sometimes...)

While the typical Huntington Beach parents of the 1950s may not expect greatness from their children—especially their daughters—they are anxious for their children to enjoy the newly available, postwar luxuries of a college degree and success in a career. Sherman is a good kid, responsive to the clues she absorbs from around her (a trait that will turn out to be one of her greatest assets as an artist). Fame and fortune as an artist are nowhere on the radar of the young Sherman's daydreams. She just likes to invent and to play, and if she's a bit insistent about it, then surely it's something she'll outgrow.

While fine art per se is not part of Sherman's early years, the adults around her do notice and encourage her creative activities. Art courses become a regular part of her high-school schedule, and when it comes time to think about college, she decides to study painting. Her mother suggests she consider art education and become a teacher. Up until then, Sherman has no acquaintance with the art world; her idea of being an artist is drawing portraits on the boardwalk or illustrating courtroom proceedings.

Shuffle Off to Buffalo

While Sherman knows she wants to go to art school, studying in New York City has never been a consideration: Her parents will only agree to send her to a school in the New York State university system, and have always felt that Manhattan (at least in the 1970s) is dangerous. Therefore, it is not an option for their young daughter.

After visiting different campuses, Sherman settles on the State University College in Buffalo and begins her freshman year in 1972.

BACKTRACK, Continued
AMERICAN CURRENT
EVENTS: 1972–73

Ms. magazine's first issue appears in January 1972, and the first printing of 300,000 copies sells out in eight days.

The U.S. Supreme Court's decision in *Roe vs. Wade* in 1973 gives American women the right to have an abortion.

Last Tango in Paris brings explicit nudity and sex to movie theaters in 1973.

The PBS documentary *An American Family* exposes the myths of the American family by following the Loud family of Santa Barbara, California, through a revealing 12-hour black-and-white documentary of their daily lives (with such dramatic, era-defining high points as Mom and Dad splitting up and the oldest son, Lance, coming out as gay).

While Sherman is in school, **Conceptual Art** is *the* big thing influencing students, teachers, and artists. Beginning in the 1960s, artists began dismantling the basic, accepted ideas about *what* constituted art, deriving most of their inspiration from their conceptual forefather, the French Dadaist **Marcel Duchamp** (1887–1968). Some basics:

Objecthood: Historically, art means "object"—it means "a thing" that exists in the world—something to be displayed ostentatiously in a frame or on a pedestal. Simple, right? Artists make stuff, that's what makes them artists. But then again, maybe not. Maybe it's the *ideas* that artists have that make them artists, not the things they *make*. If you accept the notion that creativity is the thinking part, not the making part, it's logical to call into question which objects *are* art, and to see if it's possible to have art *without* actual physical objects.

Conceptual Art: Art about *ideas* came to be called *Conceptual Art*. It began with Duchamp, who, early in the 20th century, posed a simple question: "Is a thing art because I make it, or is it art because I, the artist, name it, or designate it *art*?" (Duchamp asked this question of a number of objects and non-objects, the most [in]famous being a urinal that he presented as sculpture.) By the 1960s, this insightful gesture had helped artists develop several unusual forms of art that incorporated these concepts. Some of their favorites:

Body Art: Here, the artist's body—as well as those of friends and an occasional unknowing stranger—is the medium on which the art is created, rather than the more conventional canvas used by painters or marble fashioned by sculptors. An extremely literal example of body art is tattooing, where the body becomes the canvas and the act of puncturing flesh is the equivalent of painting.

Performance Art: Art activities that incorporate time and motion, often via music, dance, poetry, theater, and video, are called *Performance Art*. Performance Art demonstrates that visual art is not static, but is a transitory and responsive phenomenon. For example, in his May 1974 performance piece *I Like America and America Likes Me*, the West German sculptor **Joseph Beuys** (1921–1986) arrived at Kennedy Airport in New York City wrapped in felt; he was placed on a stretcher

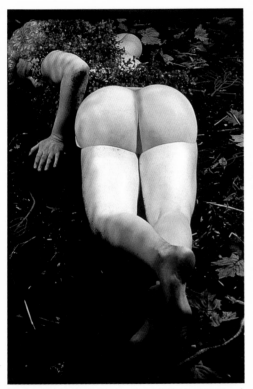

Untitled #155. 1985. 72 ¹/₂ x 49 ¹/₄" (163.13 x 110.81 cm)

and taken by ambulance to the René Block Gallery, where he lived in a room with a coyote for three days, before departing the same way he had arrived. One of Sherman's own admitted influences was Eleanor Antin, a California artist who, in the early 1970s, created "actions" by appearing in various personas (The King of Solana Beach, émigré ballerina Eleanora Antinova), while a friend took pictures of the public's reaction.

Documentation: With all this art-making that's based on performance, Body Art, and other non-object-oriented forms of production (e.g., big holes in the earth in the middle of nowhere), artists still have a deep desire to share. They want the world (and the history books) to know about their work, so the act of taking pictures of it becomes an artistic event in and of itself. Photographic records of performances, site-specific sculptures, or events are called *Documentation*. In the ironic world of the art market, these photographs become valuable art objects in their own right. The pictures become the objects of the nonobjective art, and the concept swings full-circle.

A Photographic Failure and a Painterly Yawn

Sherman enrolls in the basic studio courses—drawing, painting, and photography—and promptly fails the required photography class. The difficulties of technical photography (f-stops, light meters, apertures) stump her, and she has no interest in the subtleties involved in making "perfect" prints.

The photography fallout leads Sherman to focus on her major: painting. She is particularly adept at copying things as exactly as possible, and even does self-portraits from a mirror. The act of dissecting and replicating details appeals to her, but she quickly realizes in college that painting does not suit her. She finds her canvases "really boring" and discovers that she "can't think of any reason to paint." What to do? Looking elsewhere for inspiration, Sherman finds herself drawn to the theatricality offered by **Performance Art**, new music, and films.

She must still get through that introductory photography requirement, though. Luckily, on her second attempt at this annoying class, Sherman has a different experience. Rather than having to struggle with issues of technique and with someone else's idea of quality, she is blessed with a teacher, Barbara Jo Revelle, who stresses the ideas and concepts that make a good photograph, and who inspires Sherman to *just take pictures*. Using Conceptual Art as a guide and following her own interests, the replication-obsessed Sherman discovers after all that she does indeed like the immediacy of photography: Snapping away with a camera is a lot more direct and rewarding than trying to paint exact copies of things.

"Women now are trying to be the protagonists of their own lives, and Cindy Sherman has led the way with humor and sensitivity."

—SUSAN SARANDON, actress and activist, 1987

Getting Serious

The year 1974 is a turning point for Sherman. Having found her niche in photography, she is ready to get serious about making art. Near the end of her sophomore year, she meets a painting student named **Robert Longo** (b. 1953). Articulate, committed to his work, and driven to becoming a working artist, Longo fascinates Sherman—as she fascinates him—and the two of them soon become an item. Inspired, Sherman begins her own crash course in contemporary art by:

- poring through all the contemporary art magazines

- staging performances with artist friends (she does one in college and one just after college)

- watching experimental, foreign, and classic movies

- hanging out with her artist friends, who debate ways of making art and who brainstorm about ways of breaking into the art world.

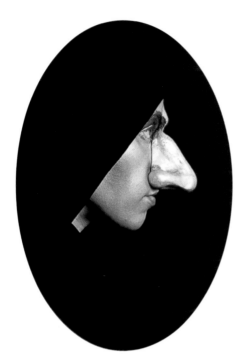

Untitled #219
1990
65 x 40"
(146.25 x 90 cm)

Hallwalls Wakes Up Buffalo

Longo's off-campus studio is part of a huge old ice house that a local foundation has turned over to art students. Along with **Charles Clough** (b. 1951), **Nancy Dwyer** (b. 1959), **Michael Zwack** (b. 1950), and some other artists who also work in the building, Longo and Clough come up with the idea of staging exhibitions on the walls of the long hallway between their studios. These shows turn this tenuous venue into a real gallery with an exhibition schedule and visiting artists. The ad-hoc space becomes known as Hallwalls, and opens as an artist-run, nonprofit exhibition space in December 1974.

Unveiled at an opportune moment, Hallwalls quickly becomes a vital and influential center. Clough and Longo's gifts—which include a knack for raising money and a determination to succeed—attract unprecedented numbers of impor-

Untitled #219
1990
65 x 40"
(146.25 x 90 cm)

tant artists, filmmakers, and critics to Buffalo. One writer describes it as
"bringing the Big Apple to SnowHo." Between Hallwalls and the
Albright-Knox Art Gallery, Buffalo suddenly finds itself on the contem-
porary art-world map. Though Sherman watches as Hallwalls grows into
a more demanding enterprise, she prefers not to become a "front" person
or to take an active role in organizational matters. Instead, she focuses on
her own work (theoretically, she is the Hallwalls bookkeeper), even
though being a member of the Hallwalls "commune" proves to be an
important learning ground that furthers her exposure to art and artists.

By the mid-1970s, when Sherman picks up a camera, photography has a separate-yet-equal history that runs parallel to the fine arts of painting, sculpture, and architecture. Its innovators are seen as artists, but the medium is considered an artistic universe unto itself. Sherman's work ultimately puts to rest the age-old feud between photography and painting by bringing photography to the forefront of the avant-garde. Here are some cherished myths to keep in mind about how photography differs from painting:

Photographs capture instantaneous moments, whereas paintings are the labor of an extended creative process.

Photographs are objective documents that accurately record people, places, events, or objects, whereas paintings are interpretive and reflect the artist's subjective point of the view.

Secrets in her Closet

Sherman has a 1970s attraction to thrift-store clothing, but, as you might imagine, given her history, she takes the vintage shopping thing further than most. Surrounded by other people's castoffs, Sherman feels she has stumbled on "the detritus" of unknown human characters. (What kind of guy would wear a bowling shirt with the name "Bruiser" stitched across the back of it? What kind of woman would carry a bag with straw pineapples dripping off it? To whom might these red fishnet stockings might belong?) Sherman does not fantasize about the previous owners; rather, she integrates the clothes into her invention of archetypal characters.

In behavior clearly reminiscent of her childhood games, Sherman develops elaborate costumes for the types of people she sees represented in her purchases. (*The woman with the fishnets would probably like this sequined bra, and Bruiser must have had a fondness for steel-gray kakhis and tube socks.*) Sherman is inspired by the impression offered by a discarded item of clothing (thrift shops are a great joy for her), and she fleshes it out—literally. On one occasion, she attends a gallery

opening disguised as a pregnant woman, and on another appears as Lucille Ball at a Hallwalls gathering where she watches TV and hangs out with the group of artists who regularly drop by. Later, when asked about this, Sherman explained that it was "a way of pacifying myself when I was depressed" and a form of "being entertaining at parties."

Sound Byte:
"Movies are and have been the only thing I have ever given myself over to study, no matter what a waste of time it seemed to be afterwards."

—CINDY SHERMAN, 1982 interview published by the
Westfalischer Kunstverein, Munster, Germany

The First Untitled Series

In 1975, encouraged by her character experiments and challenged by Longo's suggestion that she record her labor-intensive creations, Sherman makes a series of head shots featuring different characters, ranging from a dopey uni-browed guy in a locomotive hat to a fresh-faced young girl with barrettes. (A selection of these images, Untitled A-E, will later become part of her official body of work.) She also takes a series of photographs of herself and uses them like cartoon cells to produce a three-minute animation of a doll coming to life and putting on clothes (based on the childhood clothes idea).

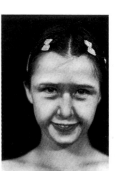
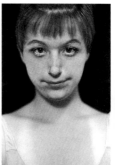
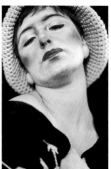

In her next project, Sherman assembles a sequential arrangement of images in a new kind of photography for her. It is a collage of storyboard images of characters—such as lumberjacks—played by Cindy herself. The photographs run in a progression along a wall, telling a story. (In 1976, a curator at the Albright-Knox Art Gallery purchased one of these images for $50 and sold it at auction in 1999 for more than $40,000.) The physical manipulation of the photographs (i.e., cutting and pasting) gives the photography a kind of secondary importance to overall collage. This work is now referred to as the **Scale Relationship Series** (see the end papers of this book) and contains elements of:

- performance (Cindy adopts a persona)

- narrative (the layout creates a change in time)

- theater (the adaptation of the character is disarmingly complete).

In her senior year, Sherman tries to change her major to photography, but the dean, thinking she lacks commitment, will not allow it. So she resigns herself to taking a B. A. instead of a B. F. A. but keeps on taking photographs. She sets up her own studio in Hallwalls and is invited to have some of her work included in a show of New York State artists at the Albright-Knox Art Gallery.

When Sherman graduates in the spring of 1976, she stays in Buffalo, determined not to feel the pressure to move to New York City. Her job

OPPOSITE

FAR LEFT
Untitled A
1975

UPPER LEFT
Untitled B
1975

UPPER RIGHT
Untitled D
1975

LOWER LEFT
Untitled C
1975

LOWER RIGHT
Untitled E
1975

as secretary at Hallwalls offers both income and the opportunity to continue learning about contemporary art.

The Movies

Movies are an important source of inspiration for Sherman and her friends. Sherman is drawn to the dramatic posturing that silent films use to convey emotion and is fascinated by standard Hollywood fare, which she calls "nostalgic films."

In early 1976, Sherman starts making **cutouts**, a series of photograph-collages with a simple and melodramatic movie or TV-like plot.

In pieces like *"Murder Mystery"*—*Whodunit #70*, she dresses herself up in all the various roles of her imagined narrative (corpse under a sheet, police photographers, stunned maid), takes

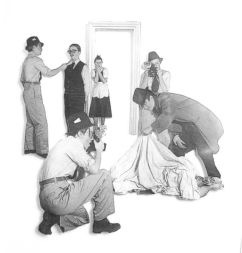

"Murder Mystery" —Whodunit #70
1976
13 $^1/_2$ x 11 $^3/_4$" (30.38 x 26.44 cm)
Gelatin silver print cutout and collage
on contoured foam board

individual photographs of the characters, cuts them out, and tapes them directly to the wall.

A Manhattan Debut and a crucial new Friend

Helene Winer, the director of Artists Space, an influential alternative space in Manhattan, visits Buffalo and gets to know the work of Sherman, Longo, Clough, Dwyer, and Zwack. They are interesting artists and Winer invites them to have a Hallwalls group show at Artists Space. Ready to present their work to New York, the bunch climb into a van and head for the city, where they sleep on the floor of the gallery while installing the show. The show arouses considerable interest and confirms Winer's instincts that there's something special about the Hallwalls group.

Sound Byte:

"Most people read ambition in a corporate way, a male way. She wasn't ambitious for public acclaim, but in a sense she was very tenacious. She was ambitious for her work."

—LINDA CATHCART, curator and museum director, on her memory of Sherman in Buffalo in 1975

Sherman nurses a suburbanite's fear of New York City, inspired by her parents' overprotective qualms, and would like to believe that moving to Manhattan is not vital to her career. Over the course of her postgraduate year in Buffalo, she gains enough experience in Manhattan to feel it possible to have a normal life there. In the summer of 1977, after Sherman receives a $3,000 NEA (National Endowment for the Arts) grant—considered a lot of money at the time—she and Robert pack up the van and move to Fulton Street, in New York City's financial district.

Urban Adjustments

Sherman's first year in the city is unpleasant. Intimidated by her new surroundings, she spends most of her first summer inside the apartment. One evening, Sherman and Longo are invited over to artist David Salle's studio. Salle is another recent art school graduate who has relocated to New York City and who has a day job in the art department of a soft-core porn magazine publisher. Sherman is fascinated by some older stock photos from Salle's office floating around his studio, and she ignores the conversation while thumbing through the images. They remind her of the various movie-inspired ideas she's been mulling over and they seem to offer clues to a story.

These images trigger a shift in focus away from her cutouts to her first new work produced since moving to New York City. From this evening forward, Sherman immediately knows what she now wants to do: create the first six *Untitled Film Stills*.

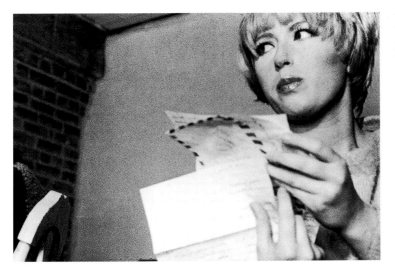

Untitled Film Stills

Sherman takes the name "film stills" from the photographs used to advertise movies in theater displays and review columns. Stills are photographic outtakes or staged reinterpretations of a key moment in a movie, intended to evoke the spirit and atmosphere of the film, and are created for quick consumption in newspapers, magazines, and theater lobbies. For older movies, film stills are black-and-white prints made in a small format (usually 8 x 10") that fit easily into envelopes

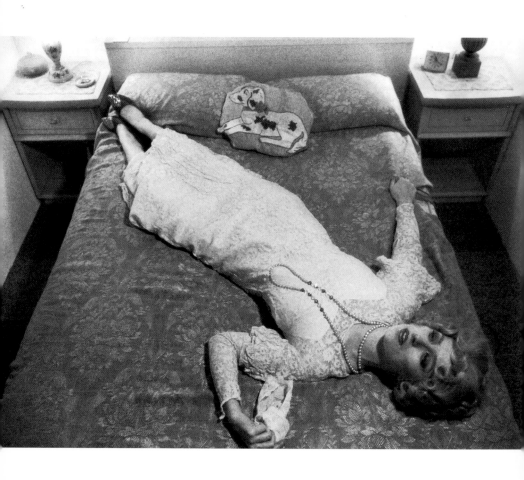

and press kits. They are advertising tools used to sell movie tickets by teasing potential viewers and piquing their curiosity about the movie.

OPPOSITE
Untitled Film Still #11
1978
8 x 10"
(18 x 22.50 cm)

Sherman's *Untitled Film Stills* are black-and-white photographs of the artist impersonating the female stereotypes of classic Hollywood movies, *films noirs*, B-movies, and foreign films. Sherman calls her stars "characters," and in a 1983 interview with *Artnews* writer Thom Thomson she explains that she is searching for "the most artificial-looking kinds of women (*Untitled #11*, for instance). Women that had cinched-in waists and pointed bras, lots of makeup, stiff hair, high heels, and things like that. To me, that's what I hated about growing up. When I was an adolescent, those kinds of role models were awful to me."

In our society, we frequently want and loathe the things we are *taught* to desire, and Sherman's *Untitled Film Stills* illustrate this cultural quandary. The images act as cues for something recognizable and familiar. They are character types we all know, since they are specific to our culture—plucky career-girl, small-town innocent, local floozy, earnest librarian. The situations in the *Untitled Film Stills* always seem charged with drama. Whatever action is going on off-screen or in the character's mind acts as a signal that something is wrong with this picture. Something is going on that we cannot know directly—we have to guess. Indeed, Sherman's control of the space beyond the camera lens adds an additional mystery to the "story" taking place within the still itself.

A Cindy Sherman Rorschach Test

Pick a film still, any film still, and play a game: What kind of character does the image conjure in your mind? What is the style of the movie it alludes to? Who is the actress? What kind of role is she playing? What's going to happen next? How did the heroine find herself in these circumstances? The answer to these questions depends on your knowledge of the cultural background of each "plot." Every viewer, then, has a different reaction to the clues offered by Sherman, and therein lies the joy and enormous appeal of the images: Viewers make associations based on their own cultural baggage and assumptions, not on anything that the artist forces on them. You are left, in effect, to interpret your own interpretations.

An *Untitled Film Stills* Laundry List

- The *Untitled Film Stills* are not based on real movies (e.g., *Untitled Film Still #43* is *not* a scene lifted from a John Ford movie).

- Sherman is the model in each of the stills and usually appears alone. (*Untitled Film Still #7* is an exception: That's Nancy Dwyer hiding under the straw hat; and in *Untitled Film Still #65*, a woman on a stairway looks up toward a stranger in the shadows.)

- Sherman uses her own possessions as props and her own apartment as the setting for the stills (as in *Untitled Film Still #13*), as well as

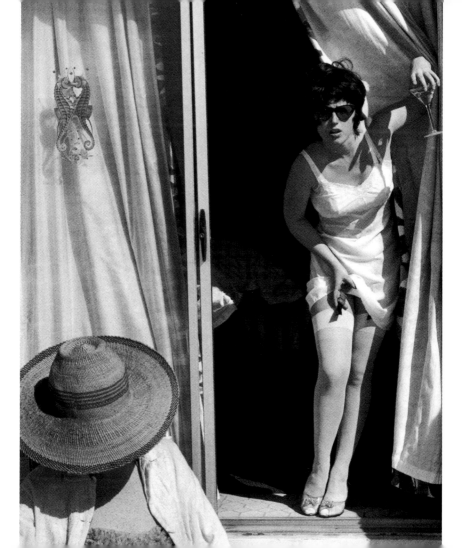

other locations, especially when she takes trips. In *Untitled Film Still #11*, she wears her mother's wedding gown and has rearranged her own bedroom to look like a cheap hotel, using as a prop a doggy pillow borrowed from Mrs. Longo.

> ***FYI*: Contemporary Masterpieces**—Sherman's *Untitled Film Stills* are contemporary art classics. Many critics and collectors consider them *the* iconic art works of the late 1970s and early 1980s. They brought international critical and popular fame to Sherman. In 1996, The Museum of Modern Art in New York bought the only complete set of the *Untitled Film Stills* for more than $1,000,000.00—significantly less than their current market value.

Serial Role-Playing— a Breakdown of the *Untitled Film Stills*

The 69 *Untitled Film Stills* fall into several distinct groups within the series:

- The first six *Untitled Film Stills* form a distinct set (*Untitled #4* and *Untitled #5* are examples). They are grainy, slightly out of focus, and very contrasty, resembling the cheaply printed, mass-produced images that often turn up at flea markets. Sherman conceives each of the images as a different role played by the same blonde "actress."

Sound Byte:

"They seemed like they were from '50s movies, but you could tell they weren't from real movies. What was interesting to me was that you couldn't tell whether each photograph was just its own isolated shot, or whether it was in a series."

—CINDY SHERMAN, *ARTnews*

- The next group is taken in the summer of 1978 at Longo's family beach house on the north fork of Long Island—Sherman's first "location" set. Sherman sets up the camera on tripod for the angle she wants, and sometimes asks someone else to snap the shutter.

- Later in 1978, Sherman selects outdoor locations in the city. Loading up a van with her props and equipment, she scouts the streets, looking for the right locales for her preconceived situations. When she finds the right place, she changes into character in the back of the van, hops out, and takes her picture (or does the setup and has someone else snap the picture), as you can see in *Untitled Film Still #21* (see page 43). This is one of Sherman's most famous and striking images, probably because the angle and facial expression are so arresting. Is the woman being chased by someone? Did she commit murder? Perhaps both?

- Preferring to work mostly in her home, Sherman heads indoors again. In pieces like *Untitled Film Still #35*, she creates her version

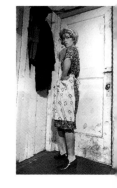

Untitled Film Still #35
1979
10 x 8"
(22.50 x 18 cm)

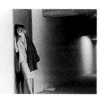

of a "sort of Sophia Loren" character from the movie *Two Women*—the voluptuous, working-class woman popular in Italian neo-realist films. That Sherman has not actually seen *Two Women* and knows of it only through film stills makes the whole attempt marvelously ironic.

- While preparing for a trip to Arizona to visit her retired parents, Sherman packs her camera and a suitcase full of props. One of her most famous images—*Untitled Film Still #48*, known as *The Hitchhiker*—is shot at sunset one evening during this trip (see page 47). Cindy arranges the camera setup and then has her father snap about five or six images of her sitting on the suitcase. At the last minute, she has him take one of her standing; this is the only one she uses.

- The rest of the series is shot in various New York locations—some outdoors, such as *Untitled #54* (on page 44), featuring the blonde victim typical of *films noirs*—and in the Los Angeles home of Gifford Phillips (same family as the Phillips Collection, Washington, D. C.), where Cindy's friend Nancy Dwyer is house-sitting in 1979.

- After shooting a number of stills, Sherman makes lists of the "types" she has not yet covered, such as the librarian in *Untitled Film Still #13*, which features Sherman's library. (Notice the copy of *Crimes of Horror: The Movies* on her shelf.)

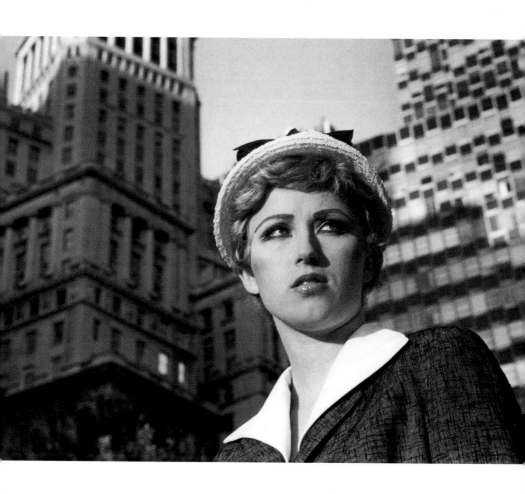

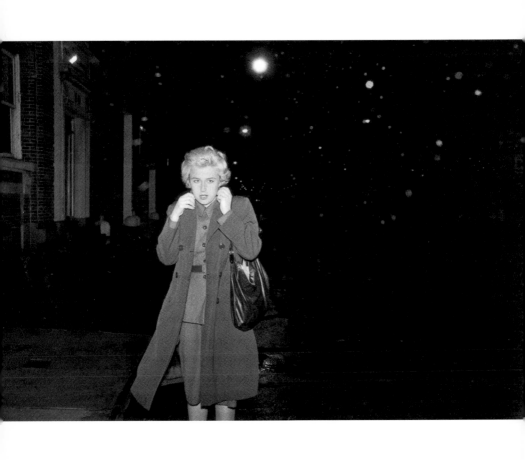

Part of the Downtown Scene

Having settled into New York City life, Sherman—like most young artists—gets a job to pay the bills. She takes a job at Macy's that lasts only one day, and then is hired by Helene Winer as a receptionist at Artists Space. The gallery job, like the bookkeeper job at Hallwalls, offers Sherman an opportunity to meet people and to become an active part of the New York art world.

At the same time, Longo has a job organizing exhibitions at another alternative space called The Kitchen, which further expands their acquaintance with the emerging New Wave and punk musicians, and with performance artists such as Eric Bogosian.

OPPOSITE
Untitled Film Still #54
1980
8 x 10"
(18 x 22.50 cm)

The *Pictures* Generation

The year 1977 offers a defining career moment to Sherman when the critic Douglas Crimp curates a show called *Pictures* at Artists Space. At first glance, this show appears to be no big deal—just another month-long exhibition of emerging artists. But *Pictures* is different, and people realize this quickly. There are only five artists in the show, and Sherman is not one of them.

But by dint of her proximity to the show and to the discussions surrounding the show, Sherman quickly becomes associated with the critical debate that surrounds the show. Crimp includes her in the catalogue text when it is later published in *October* magazine, and it is clear that Sherman is essential to the first post-Modernist art criticism.

(*Quick primer*: Modernism is about the progressive idea of formality and purity; post-Modernism is about appropriating ideas wherever you find them; it's an attitude of "anything goes," with everything being "open game." Post-Modernist artists were free to "borrow" anything from anyone, with no pretense of originality.)

With *Pictures*, Crimp advances the theory that a lot of young artists are taking the ideas of Conceptual Art (with its abstract and non-object-oriented notions) and introducing them back into object-oriented, representational art—i.e., art in which figures and objects are actually

TOP
Cindy Sherman
at Artists Space
1978

ABOVE
Untitled Film Still #43
1979. 8 x 10"
(18 x 22.50 cm)

OPPOSITE
Untitled Film Still #48
1979. 8 x 10"
(18 x 22.50 cm)

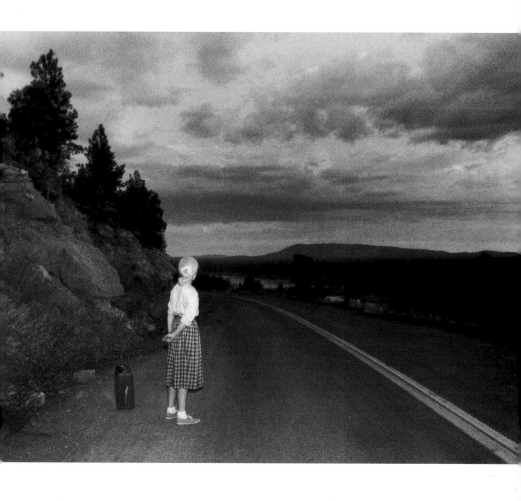

Post-Modernism is a term used to describe an intellectual change in the approach to making art. Some of its features: The accepted way of identifying art—by **medium** (i.e., what art is made of)—is broken down (that's a photograph, he's a photographer; that's a movie, she's a filmmaker; that's a guy sticking pins in his body, he's an insane person). Artists begin using any medium they want for the job at hand, often employing several at once, such as Sherman's use of performance, costumes, and photography. The definitions of art mediums and practices (i.e., how art gets made) change. Nontraditional forms of art-making emerge (as we saw with **Body Art** and **Performance Art**). Artists want to take apart and examine microscopically the myths they've been taught in their culture. This practice is called **deconstruction**. Artists challenge the modern idea of creative originality by borrowing images from the media or from art history and representing them in an altered context. This is called **appropriation**.

recognizable as such. Like Sherman, all of the *Pictures* artists are inspired by the images of mass media, and with this show, Crimp is one of the first critics to capture a historic moment, the start of post-Modernism.

In a Rut

Some of the *Untitled Film Stills* make up Sherman's first solo exhibition, held at The Kitchen in 1980, but by now, she is beginning to feel that the stills have run their course. She is tired of "lugging the equipment around and having someone else there to take the picture and dodging people on the street or waiting for everybody to clear out." So it's time to be thinking about new projects.

The Work of some of Sherman's Peers

Next thing they know, Sherman and her peers are being called the *Pictures* Generation. The group includes:

- **Jack Goldstein (b. 1945):** He came to New York from the California Institute of Arts, bringing with him ideas based on film that he translates into paintings, art films, and "image records" inspired by the MGM logo and media-savvy outtakes.

- **Robert Longo (b. 1953):** He makes sculptures, drawings, photographs, and films of men and women dressed in the power styles of Wall Street, who jump, twitch, and wrestle like punk-rock slam dancers.

- **Sherrie Levine (b. 1947):** She copies original art masterpieces and presents the reproductions as her own, thereby undermining the idea of the power contained in an "original."

- **Richard Prince (b. 1949):** He excerpts magazine ads of Marlboro Men and cartoons from *The New Yorker*, which act as banal surrogates of masculine identity.

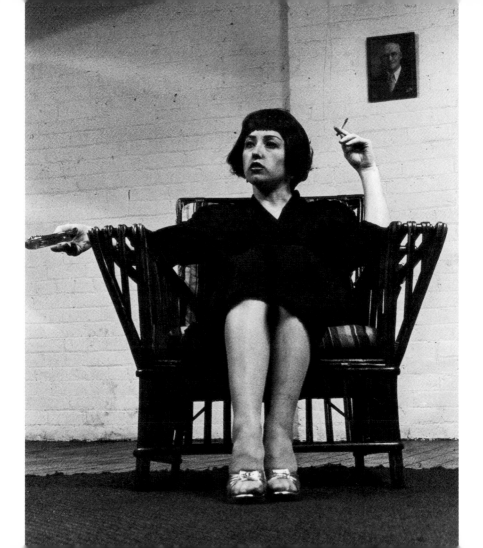

Changes on the Home Front

In late 1979, Sherman and Longo part ways as a couple but remain friends. Sherman settles into her own loft and, by late 1980, into a new relationship with artist **Richard Prince**. Since both Sherman and Prince use photographs for a group show in which they have been invited to participate at the Pompidou Center in Paris, they produce a collaboration that has become known as *Double Self-Portrait.* In these two images, Sherman and Prince mimic each other by dressing up as the same gender-neutral character, shown only from the neck up and revealing nothing of the male or female anatomy. The portraits comment on gender and on what it means to be male or female, but they also show how photography can mislead and misrepresent. Both artists wear a man's suit, eye makeup, and a wig that could swing either way into male or female. The placement of the figures and the cropping of the image neutralize any other gender-defining characteristics.

While *Double Self-Portrait* is a term that neither Sherman nor Prince would use under normal circumstances, in this case the title reinforces the ambiguity of their subject. Who is being profiled in these photographs? After all, there are two people in the picture. But wait, are they the same person? Or are they imitating the same character? The title is deliberately confusing: It is clearly an image of two people trying to merge or to obscure their individual identities.

TOP
Untitled F (2 of 2)
1980/87. 7 ½ x 5 ½"
(16.88 x 12.38 cm)

ABOVE
Untitled F (1 of 2)
1980/87. 7 ½ x 5 ½"
(16.88 x 12.38 cm)

OPPOSITE
Untitled Film Still #16
1978. 10 x 8"
(22.50 x 18 cm)

This is the only collaboration the artists made together. Years later—
and after they've broken up as a couple—Prince produces an edition
of ten of these *Double Self-Portraits* under his own name, without con-
sulting Sherman, whose "name value" is a major reason the images
would have value to purchasers. In response, Sherman issues another
edition of ten under her own name.

FYI: **Limited Editions**—Artists who work in mediums that are intended
to be reproduced (photography, prints, bronze, and video) usually make
editions of their work— that is, a limited number of originals that are
authorized by the artist. When an artist signs an editioned work of art,
he or she normally notes the image number and the quantity of pieces
within the edition by writing both on the piece in a fraction. Ergo, 1/10
is the first print in an edition of 10 prints. Sherman's edition sizes have
ranged from as few as 3 to 5 for some *Untitled Film Stills*, to her most
common editions, which run between 10 and 15. In cases where she creates
a piece for fundraising purposes (e.g., for alternative artists' spaces), she
authorizes editions of more than 100. (And yes, you guessed it, the
smaller the edition, the more expensive the piece.)

The Rear-Screen Projections: 1980–81

For her next project, Sherman wants "to look like I was on location without having to be on location." She achieves this effect through rear-screen projections, a long-time Hollywood studio technique in which a projector is used—from the rear, of course—to simulate the experience of being outdoors. When executed poorly (as in the case of a car's rear-window view in movies from the 1940s and 1950s), the effect is laughably false. You can tell the scene was filmed in a studio.

Untitled #76
1980
15 $^3/_4$ x 23 $^3/_4$"
(35.44 x 53.44 cm)

There are two features to look for in the rear-screen projections:

- **Color:** This is Sherman's first work in color. Though she wants to maintain some of the outdated feeling of the *Untitled Film Stills*, she prefers to work in color here, despite her apprehension that color sometimes looks "too real" to her. The rear-screen projection offers a solution: It is an attempt to work in color while circumventing the documentary "reality" that color evokes.

- **Backgrounds:** Slides are projected onto a screen to make it look like Sherman is on location. Partly by intent, but partly as a result of the technical difficulties she experiences with her equipment (she uses an ordinary slide projector), the rear-screen projections are accentuated by a visual break between Sherman, the model, and the backgrounds behind her. Anyone can see that this is a simulation. The result is blurry, hyper-flattened backdrops, and crisply

focused images of the three-dimensional Sherman. Technical problems with lighting affect pieces like *Untitled #66*, which is surrounded by a dark, bleeding edge. Sherman explains that "the blurry imagery was a chosen way to 'match' foreground and background, with neither becoming totally unrecognizable—a problem when the lighting is limited."

If the *Untitled Film Stills* take the nostalgia of B-movies and *film noir* as their starting points, the rear-screen projections mimic the more contemporary TV shows of the 1960s and 1970s. While still filmic, they capture youthful characters who seem to come from small-town, middle-class America in the 1960s. The hip girl in *Untitled #76* (on page 53) swigs beer with a self-assurance you would never find in the *Untitled Film Stills*. These girls could be the (cooler) peers to those in the last photographs of *A Cindy Book*.

Why is Everything Untitled?

As we've noted, with the exception of the *Untitled Film Stills*, Sherman has never titled any of her works. The rear-screen projections and the names of Sherman's series are mere descriptions, often coined by other people. When asked why she doesn't title her works, Sherman responds that she does not want to get in the way of someone else's thinking or inner associations about one of her pieces. If, for example, Sherman has a vague notion of a particular actress when she starts a piece (say it's Kim Novak), and if *you*

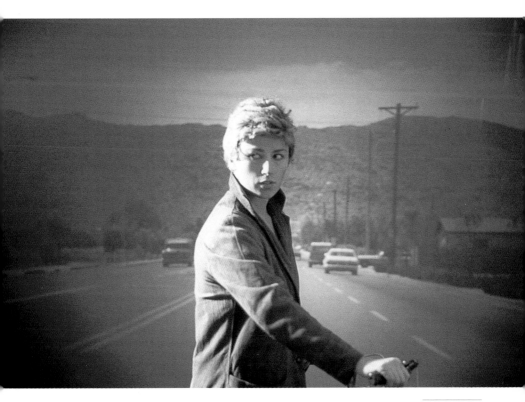

Untitled #66
1980
15 ³/₄ x 23 ³/₄"
(35.44 x 53.44 cm)

think it's Marilyn Monroe when you look at the photograph, Sherman has no problems with that. But if she were to title the piece *Kim Novak*, she feels that this would be forcing you to come to the work from the point of view of Sherman's association with Kim (which, by the way, you'd never be able to know anyway). What she wants is for viewers to approach the work from their own associations, not from hers.

Centerfolds

In 1981, Sherman is invited to produce a two-page special spread for the important contemporary art magazine *Artforum*. Inspired by the horizontal format of girlie magazine centerfolds, she begins a new group of images:

- By necessity, the figure is often lying down—you can't fit a figure into a horizontal space unless it's reclining. Is there significance to the fact that prone women tend to look vulnerable? A lesson from the *Untitled Film Stills*: Standard interpretations of female sexuality and sensuality, especially in men's eyes, are enhanced by vulnerability.

- In general, photographs of centerfolds tend to be shot up-close and personal, an approach that borders on the invasive.

- The tight cropping of Sherman's Centerfolds leaves little room for—or interest in—extraneous information. Sherman's idea? That

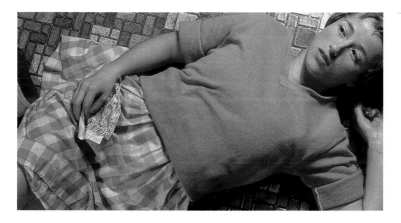

Untitled #96
1981
24 x 48"
(54 x 108 cm)

viewers of centerfolds don't want anything distracting them or blocking their view.

- There is a flattened sense of space, as if the viewer is on top of the model. While this may leave you feeling uncomfortable, it may also convey a kind of voyeurism that arouses.

Sherman adds her own ingredients to the list of centerfold conventions by making her own Centerfolds huge, almost lifesize (24 x 48"). Her women are distinctly *not* your normal centerfold material; they are decidedly not the teenage boy fantasy of a naked, more experienced woman. Not only are the subjects of Sherman's Centerfolds clothed, but they tend to look distraught, which adds to their vulnerability. The

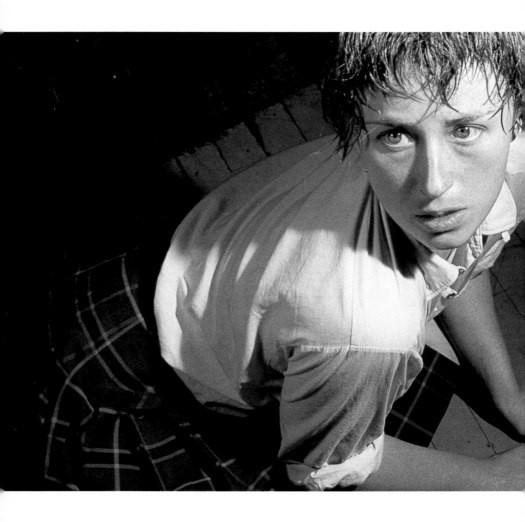

theatrical lighting and color are more sophisticated than those of the rear-screen projections, and this underscores the melodrama.

The invasive nature of Sherman's technique seems to heighten the anxiety felt by her Centerfold subjects, and all of this makes us feel as if we're witnessing something private, something forbidden. Sherman tells an interviewer, "I think I showed this part of these people you see in centerfolds, the part that the photographer doesn't want to take pictures of."

Take, for instance, *Untitled #92* (at left). Notice the concerned, foreboding expression on the model's face. Again, questions pop into mind: Why is she wet? Is she on a dock? Is that a school uniform she's wearing? Where is that light coming from? And what exactly is she looking at in that way?

Untitled #92. 1981. 24 x 48"
(54 x 108 cm)

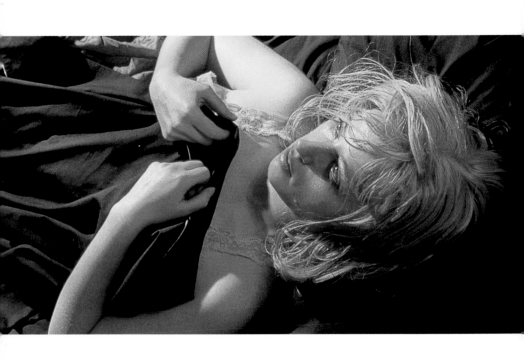

Controversy...and a Surprise

Ingrid Sischey, the *Artforum* editor who made the assignment to Sherman, rejects the images, fearing that her readers might mistake them for real centerfolds, even though one of the missions of a magazine like *Artforum* is to embrace potentially controversial art long before the public at large does. *Untitled #93,* in particular, creates a stir among feminists, who argue that the young woman appears to have been sexually assaulted. But Sherman explains that she is merely depicting a hung-over girl who hasn't had enough sleep and whose makeup is smudged. Metro Pictures later exhibits the photographs to great acclaim. The controversy illustrates the confusing power of Sherman's images and the defensive reactions they can evoke in viewers. It also points up the potential hostility to which Sherman exposes herself by not providing titles or descriptions: If it's up to viewers to interpret a picture any way they wish, then their interpretation may differ radically from that of the artist.

Feminist issues—or, for that matter, any questions of identity—are an important part of discussions about post-Modernism. With the Centerfolds, Sherman finds herself thrust into the debate. Obviously her photographs critique women's roles in the 1970s, 1980s, and 1990s, but viewers feel hard-pressed to get a handle on Sherman's position: Is she, or is she not, a feminist?

OPPOSITE
Untitled #93
1981
24 x 48"
(54 x 108 cm)

Sherman explores the method by which images convey meaning, not only from the viewpoint of her own experience as a woman, but also through her interests as a visual artist. She feels no mandate to reassure her viewers with an explicit explanation of her position. Whether or not that makes her a feminist depends on the viewer's own reading of Sherman's images, and not on anything that artist has or has not represented in her work.

Ironically, when the Centerfolds are shown at Metro Pictures in 1982, not only are they Sherman's first big commercial success, but at the age of 28, she finds herself the toast of the international art world. Sherman's appearance as subject of her own work belies the fact that she is an extremely private person who prefers to remain detached from the growing hype that swirls around her in the 1980s. The Centerfolds experience, provoked by *Artforum*'s rejection of the images, bewilders her and leaves a nagging disappointment that her work could be misunderstood. Along with the sudden art-world stardom, this leaves her feeling that the whole episode is absurd.

Sound Byte:
"I wanted to do a centerfold that was really uncomfortable to look at. You would open it up expecting to be titillated and then feel uncomfortable looking at somebody in this vulnerable position."

—CINDY SHERMAN, 1983

FYI: **A Gallery called Metro Pictures**—In the fall of 1980, Helene Winer (former director of Artists Space) and Janelle Reiring (previously with Castelli Gallery) open a gallery called Metro Pictures in SoHo. The gallery's media-inspired name announces its mission—to represent the new art exemplified by the Pictures Generation. Metro Pictures has now moved to the West Chelsea section of Manhattan, where most of the innovative galleries have relocated in the wake of staggering increases in real-estate costs in SoHo and the resulting shopping-mall, tourist-glutted atmosphere of that once-quaint artists' quarter.

Bad Girls and Pink Robes

In late 1981 and 1982, the work following the Centerfolds is the result of further effort to have a successful project with *Artforum*. It becomes known as the Pink Robes, which are followed by her "Color Tests." Sherman's goal in these new, vertical photographs (i.e., the models are not lying down) is to show a "stronger, more daring and aggressive sort of character, that is even less female, possibly slightly masculine."

In the Pink Robes images (such as *Untitled #98*, on page 64), Sherman does not wear makeup, a wig, or any other disguising props. Instead, she uses dramatic illumination. While the vertical format removes some of the awkward vulnerability of the Centerfolds, Sherman

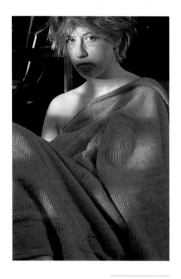

continues to think about pornography. The pink chenille bathrobe, the direct gaze, and the lack of props might not bring porn immediately to mind, but Sherman sees the Pink Robes as another narrative moment in the working life of a centerfold model—this time, the model is taking a break from her work and being her "real self."

Me Me Me

Most viewers think that the pictures must be about Cindy Sherman, since she appears in them. Wrong. The Pink Robes photos bring this issue to the fore, because we see Sherman at her most unadorned—and therefore, as the logic goes, at her most "natural." It does not beg the question of "Who is the real Cindy Sherman?" but rather the more important question of "Does it matter who the real Cindy Sherman is?"

While Sherman acknowledges that questions about her own identity cannot be avoided, due to the nature of the work—a Cindy Sherman retrospective, after all, means looking at hundreds of pictures of Cindy Sherman—she does try to avoid this kind of discussion, since, for her at least, it is not important. Peter

Schjeldahl, art critic at *The New Yorker*, once told Sherman that a *Where's Waldo?* attitude should be viewed as an entry-level way of understanding her art. That's a generous way of putting it—i.e., if the meaning of the work seems obscure, one can at least grab hold of the idea that this is indeed a self-portrait of the artist. But unless you realize that the photograph is *not* about her—that it is actually about *your* perception of the figure she is presenting—then you will reach conclusions that are groundless and without merit.

Still Girls?

At the same time as she creates the Pink Robes, Sherman works on another group of vertical shots that have been dubbed the Color Tests. In addition to playing with her character types, Sherman experiments even more with theatrical lighting through the manipulation of scenes with gels and colored lights. As we see in *Untitled #102* and *Untitled #112*, the Color Tests feature tough and occasionally androgynous women, darkly lit and shadowy backgrounds, and tightly cropped vertical shots.

In both of these new groups of images, the film, TV, and soft-core porn references of the past have vanished, leaving things even more ambiguous, playing more with ideas of sensuality and "reality" (a "real" person caught in a "real" moment, not an actress or a model at work).

ABOVE
Untitled #102
1981
49 x 24"
(112.25 x 54 cm)

RIGHT
Untitled #112
1982
45 ¼ x 30"
(101.81 x 67.50 cm)

Boom Times

In the booming economy of the 1980s, the art world gets caught up in the fabled bull market that symbolizes the second half of the decade. Much of the energy in the art world is devoted to cultivating and "developing" the social and financial elite. Peter Schjeldahl characterizes the 1980s as a decade preoccupied with "the sex life of money." Ironically, the 1980s is also an era of intense theoretical critique, as intellectuals heatedly deconstruct cultural myths. Sherman finds herself shuttling back and forth between the two.

Sound Byte:
"I am trying to make other people recognize something of themselves rather than me."
 —CINDY SHERMAN, 1986

Even though she is a hot commodity by the mid-1980s, Sherman's natural reserve keeps her from getting swept up by art-world phoniness and glitz. In fact, a few years earlier, after leaving Longo, she relocated to the rear of an old building on Fulton Street, cooked on hot plates, showered in a plastic stall next to a sink, and used a toilet down the hall. But in 1982, she is one of the few photographers included in the important international exhibition of Contemporary Art, Documenta 7, in Kassel, Germany. By the mid-1980s, she moves to Tribeca and receives important institutional support in the form of

exciting new shows and major acquisitions. Her work is purchased by The Museum of Modern Art and The Metropolitan Museum of Art in New York, The Tate Gallery in London, and The Stedelijk Museum in Amsterdam. At 29, she becomes one of the youngest artists ever to receive a Guggenheim Fellowship.

Let's get Fashionable!

In late 1982, Dianne Benson, the owner of a chain of trendy Manhattan clothing stores called "Dianne B," commissions Sherman to create a group of fashion photos that will run as ads in *Interview* magazine. Sherman receives $500 per ad and retains all rights to the images she creates. As she has done successfully throughout her career, Sherman benefits from the commercial assignment itself but also from the subsequent control over her images. For the Dianne B gig, Sherman

Untitled #119. 1983. 45 ¹/₂ x 94"
(102.38 x 211.50 cm)

takes home samples from various lines of clothing—including designs by cutting-edge designers Rei Kawakubo of Comme des Garçons and Jean-Paul Gaultier—then makes the photographs and returns the clothes.

The impulses that had driven her games as a child and as an adolescent reemerge when she is confronted with this haute couture, since the assignment represents another piece of culturally stereotyped femininity: clothes for the grown-up Barbie. Most clothing ads promise the reward of "Wear this, and your life with improve." But rather than make her feel sexy or sophisticated, these clothes leave Sherman feeling awkward and uncomfortable. The result? Sherman's "Dianne B" pictures are boisterous and silly, and have an element of slapstick humor—all in the spirit of Benson's own "have fun with it" attitude. The photos are decidedly unglamorous, and Sherman describes her approach as "attacking the clothes."

Sound Byte:
"I wouldn't think I would have to call myself a feminist, because I think it's redundant to be a woman and to call yourself a feminist."

—CINDY SHERMAN, 1999

In late 1984, as a result of the Dianne B project, the designer Dorothée Bis suggests a similar series for French *Vogue*. This time, however, instead of creating "happy, goofy, funny" pictures, Sherman aims for something that will "rip open the French fashion world." Partly because of the oppressive quality of the clothes, Sherman decides to make ugly, depressing, and gory pictures—i.e., to make the clothes unbeautiful.

You'll see in the Fashion photographs that the ones for Dianne Benson (*Untitled #119, #122,* and *#131*) tend to be light and fun, while the Dorothée Bis pictures (*Untitled #132* and *#138*) are more offputting and repulsive:

- *Untitled #119*: It is geeky, overblown, and overbearing, like an embarrassing friend who has imbibed a little too much.

- *Untitled #131*: Think of your dopey next-door neighbor trying to be Madonna who will never achieve the look she desires, regardless of her endearing efforts.

- *Untitled #132*: A third-degree burn survivor might not be your model of choice when trying to sell garments.

- *Untitled #138*: Is that blood on her hands? Whatever it is, she's pleased with herself, and who wouldn't be after figuring our how to tie that tie? Or is her facial expression merely that of a homicidal maniac?

TOP
Untitled #131
1983. 94 ³/₄ x 45 ¹/₄"
(213.19 x 101.81 cm)

BOTTOM
Untitled #122
1983. 74 ¹/₂ x 45 ³/₄"
(168 x 102.94 cm)

Untitled #138
1984
77 x 48 ¹/₂"
(173.25 x 109.13 cm)

Going Gothic

In 1985, by the time Sherman makes the darkly fanciful *Untitled #140*, a serious change has taken place, and it is not pretty. Her next commercial assignment, this one for *Vanity Fair*, requires her to make pictures based on fairy tales. Sherman finds it an easy leap from the world of fashion to the world of the Brothers Grimm, with its stories of wonder, belief, hope, and horror. But instead of the gentle form of horror that most children are titillated by in the *Fairy Tales* by the Grimms, Sherman's is a surreal, horrific form of the genre, with wigs, prostheses, intense colors, and sharply contrasted lighting. It is at this stage in her career that Sherman truly enters a Gothic land of macabre and barbarous creatures, abandoning the "real" world for the fabled realm of fairies, ghouls, goblins, and freaky, pig-faced girls with bad hair and wounded expressions.

Sound Byte:
"No matter how much people try and clean up violence in fairy tales, it remains what children like best."

—CINDY SHERMAN, 1987

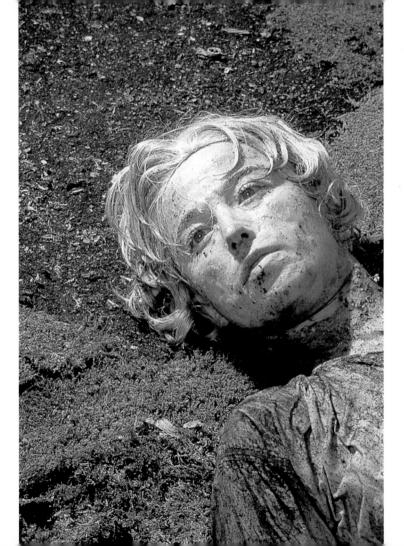

Sherman pulls out all the stops imposed by cautious editors and parents, bringing front and center the perverse undertones in bizarre fairy tales of boiled babies and hirsute grandmothers.

OPPOSITE
Untitled #153
1985
67 ¼ x 49 ½"
(151.31 x 111.38 cm)

As usual, she has no agenda to illustrate a specific story, but extracts details that appeal to her and uses them as she wishes. Sherman wants these photographs to "fill in the gaps of what I really wanted to be reading about" and promptly goes on a shopping spree, buying masks, medical prostheses, theatrical paint, dirt, grass, pebbles, and toys.

In the Fairy Tales, there is greater attention to backgrounds, props, and depth of field than there was in the Centerfold pictures or the *Pink Robes* series. Here, she combines the phony, the kinky, and the taboo to construct a fairy-tale world of a parent's worst imaginings. *Untitled #153*, for instance, offers a David Lynch-like version of our darkest fears displayed in crisp and luscious color.

Sound Byte:
"The world is so drawn toward beauty that I became interested in things that are normally considered grotesque or ugly, seeing them as more fascinating than beautiful."

—CINDY SHERMAN, 1996

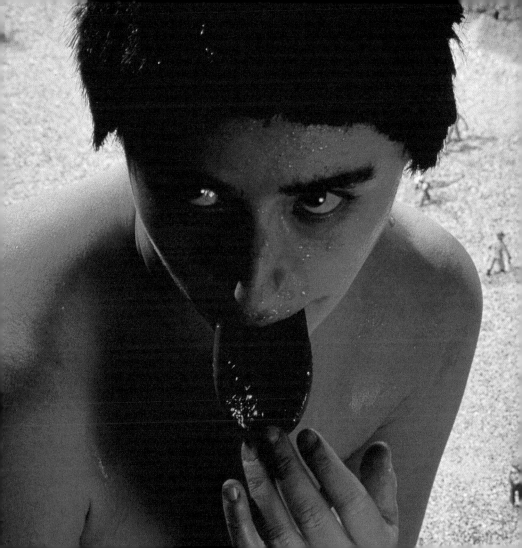

Seeing the Links

A good way to understand the art of Cindy Sherman is to watch for relationships that exist between the various images she creates. The Fairy Tales combine key elements from her previous works, as in *Untitled #146* (on page 83), which presents melodramatic theater in the extreme. What's new here is the prosthetic props of breasts and teeth, and the New Wave metallic backdrop—it's like a genie sprung from her bottle who goes wild in a disco. As for things we've seen before, consider the implied storyline, which borrows the earlier technique of manipulating off-camera space: Does the open bottle at her feet mean that the genie has just been released? Who released her? Is there a person (offstage?) to whom she is baring her teeth? Consider also the centrally focused, meticulously cropped vertical shot that allows the stage to be set

Untitled #150. 1985
49 $\frac{1}{2}$ x 66 $\frac{3}{4}$" (111.38 x 150.19 cm)

without drawing too much attention away from the figure. We have seen that before. But the Fairy Tales expose an essential element of the artist's work that has *not* been seen before: As she segues from children's stories to unmitigated gore, we see a distinct shift toward repellent, gruesome images.

Sound Byte:

"The shock (or terror) should come from what the sexual elements are really standing for – death, power, aggression, beauty, sadness, etc."

—CINDY SHERMAN, notebook entry, 1992

What a Disaster!

OPPOSITE
Untitled #146
1985
72 ¹/₂ x 49 ³/₈"
(163 x 111 cm)

Following the Fairy Tales, with the introduction of some horrific imagery, Cindy's work takes a turn toward what has become known as the Disaster images, created during the mid- to late 1980s. ("This was when I was responding to my ambivalence about the 'collector frenzy.'") While creating these photographs, Sherman suspects that people may have a negative reaction to the scary elements, but that in the end they will find them funny. To her surprise, many remain shocked by the images and cannot see the sheer humor in them. The irony—and even the abstract beauty—of these photographs is lost on many viewers.

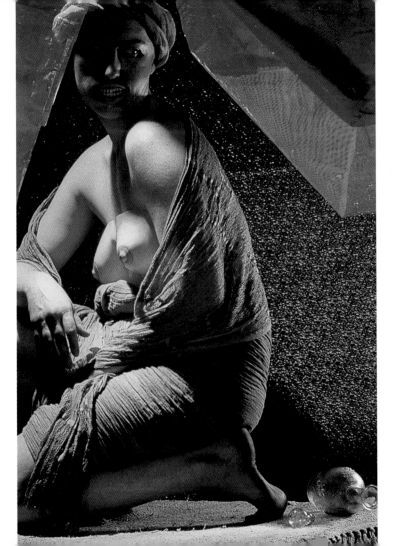

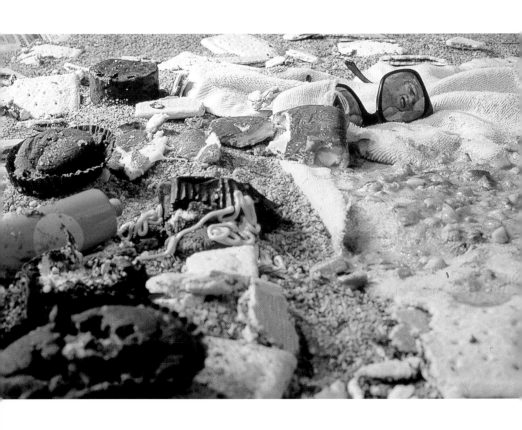

Artists are not always troubled when the public fails to *get* their work. In fact, they sometimes consciously create works that their audience will find difficult to embrace, since (they believe) if the works are too easy, they might be perceived as decorative art. Like all artists, Sherman thinks about this issue and realizes that some of her collectors may indeed be offended and/or puzzled by her work. Nonetheless, she enjoys the challenge of creating art that one might not consider "beautiful," and the outlandish and (to some people) deeply troubling Disaster photographs suit her fine. They comment on the chaos and violence in our society, in which human beings are often objectified, violated, and even destroyed.

- *Untitled #175* captures a human being only through a reflection in her Ray-Ban sunglasses. This image, which evokes perhaps the detritus of a beach party, gives insight into the

ABOVE
Untitled #188
1989
43 ¹/₄ x 65"
(97.31 x 146.25 cm)

OPPOSITE
Untitled #175
1987
47 ¹/₂ x 71 ¹/₂"
(107 x 161 cm)

debauchery that has no doubt ensued, with the partially consumed and sand-encrusted Pop Tarts, chocolate junk food, Coppertone, and a pool of chunky vomit as stark reminders of the revelries.

- And how about the gruesome though artificial derriere presented in *Untitled #177*? The intense color and lighting make this piece an ironically attractive abstraction. Even the person in the upper right of the image seems mesmerized by what the viewer can see.

- *Untitled #179* (see page 88): In 1987, this image is a safe-sex admonishment—practice makes perfect, no matter how abject the learning process. Sherman seeks to highlight the artificiality of what she is doing, and even though she aims for the squirm response, she makes no attempt to con the viewer. "It's much easier to absorb—to be entertained by it, but also to let it affect you psychically—if it's done in a fake, humorous, artificial way," Sherman explains.

OPPOSITE
Untitled #177
1987
43 $^{1}/_{3}$ x 73 $^{1}/_{4}$"
(97.43 x 164.81 cm)

As usual, the viewer can find the artist lurking somewhere in most of the Disaster pieces, but there are instances when Sherman removes herself from the action in order to use dolls, props, and human surrogates. In *Untitled #188* (on page 85),Sherman is absent, leaving an inflatable plastic doll on its back, lipstick smeared, as if a sexual act has occurred, or one of nonsexual aggression or violence.

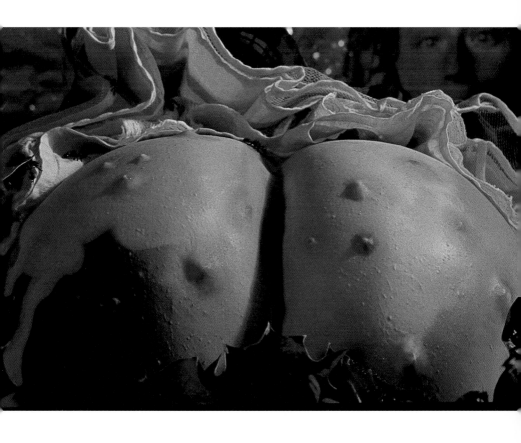

Sound Byte:
"There's this built-in curiosity about the 'real' me that other artists don't necessarily have to deal with."

—CINDY SHERMAN, 1999

Tackling a new Series

In 1987, The Whitney Museum of American Art hosts Sherman's first major retrospective, a "mid-career" show that has become increasingly common in the art world. She is 33 years old. While such a retrospective is an honor, it places a kind of uncomfortable pressure on a young

OPPOSITE
Untitled #179
1987
71 ¹/₂ x 47 ¹/₂"
(160.88 x 106.88 cm)

89

ABOVE
*Madame de
Pompadour (née
Poisson) Soup Tureen*
1990. Porcelain
(Overall) 22 x 14 ¹/₂
x 11 ³/₄" (49.50 x
32.63 x 26.44 cm)
Produced by
Artes Magnus

OPPOSITE
Untitled #224
1990. 48 x 38"
(108 x 85.50 cm)

artist to contemplate her future work. It isn't long before she begins her next project, the History Portraits.

In 1988, Sherman receives a number of invitations that relate to her interest in working with images inspired by Old Masters history figures:

- Artes Magnus, producer of limited-edition tableware art objects, invites Sherman to create an edition of a dinnerware service, a tea service, and a soup tureen in porcelain, then arranges for her to visit the celebrated French porcelain house, Limoges. Using original molds from 18th-century designs made for Madame de Pompadour, mistress of King Louis XV, Sherman creates a series of porcelain

objects, modeling for each of them in period dress à la Sherman. The marvelously funny china soup tureen, avec Madame Sherman de Pompadour on it, is one of these creations. Madame de Pompadour's maiden name was "Poisson" (French for "fish"), and when Sherman is creating the motifs for the soup tureen, she replaces the Fleur de Lys flowers on the 18th-century design with little fish. The Artes Magnus assignment would prove to be the tangible beginning of the History Portraits.

- Later in the year, Sherman transfers her history-portrait idea from the china tureen onto the flat walls of Metro Pictures when she includes a Madame de Pompadour-esque image as one of her historically based images for a 1988 group show at the gallery. It is a huge hit.

Sound Byte:
"Believing in one's own art becomes harder and harder when the public response grows fonder."

—CINDY SHERMAN, 1982

- In 1989, to commemorate the French bicentennial, Sherman produces a group of images for a Parisian gallery, Chantal Crousel, based on characters from the French Revolution.

- Also in late 1989, Sherman is invited to spend a few months living and working in Rome. This gives her a chance to concentrate further on the

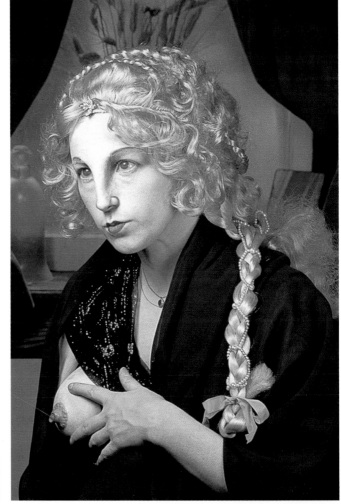

History Portraits. By 1990, she has returned to New York and has produced 35 of them, ranging from the easily identifiable, such as *Untitled #228*, where Judith holds the head of Holofernes (*recall:* in the Book of Judith, Holofernes is Nebuchadnezzar's general, killed by Judith), to the hilarious *Untitled #255,* in which, inspired by Botticelli's *Portrait of a Woman* (c. 1490), she pokes fun at the Old Masters' treatment of the female anatomy by having an aristocrat squirt fluid from her breast, to the marvelously beschnozzeled figure in *Untitled #219* (on page 26). Sherman is the sitter in the History Portraits, but her use of elaborate makeup, costumes, and fake breasts and noses lets the viewer know that this is definitely post–Fairy Tales. The History Portraits are such a huge success that there is a veritable stampede to see them when the show opens at Metro Pictures and nearly a bidding war for them on the floor of the gallery.

As she had done for both the *Untitled Film Stills* and the Fairy Tales, Sherman researches the History Portraits with great care. She haunts bookstores and the flea markets of Rome; she investigates period costumes and props; she analyzes poses, expressions, backgrounds, and lighting techniques. She picks up on the eccentric oddities in many Old Masters paintings and takes glee in working these historical quirks into her pictures. As ever, she has no preconceived notions of what she will ultimately create, but allows herself to be influenced by, say, the antique dress that someone lends her.

Disturbances in the Field

The following year, a small group of photographs that incorporate limbs, blood, dirt, and gore emerges from Sherman's studio. They have become known as the Civil War Pictures, and while the name is more specific than usual for a Sherman series, it describes rather accurately these apparently murderous snippets of mayhem and injury. *Untitled #244*, on page 99, is a tightly cropped epidermal shot with just enough blood to trigger a flinch. No figure, no identity, just meat. The photograph is disturbing enough to make Sherman fans wonder what else she is working on. It's not long before they find out.

The Sex Pictures

What's next jumps from the refined world of history into the world of sexual pandemonium. Some viewers are somewhat troubled by what they consider to

Untitled #250. 1992
50 x 75" (112.50 x 168.75 cm)

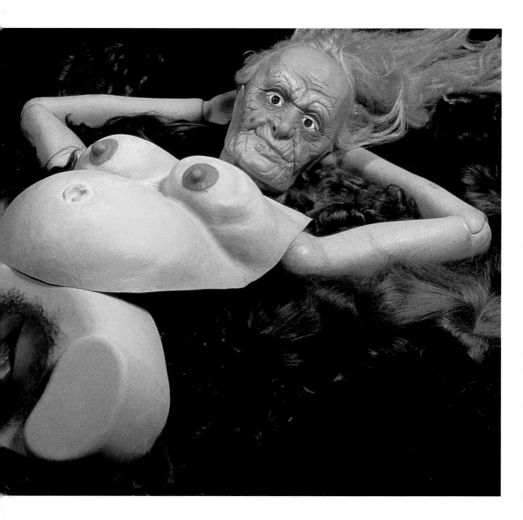

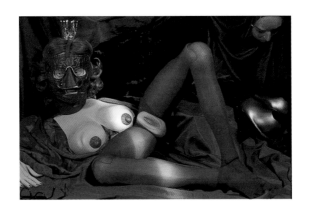

be extreme bad taste in these images, but Sherman's notebooks describe her ambitions for the Sex Pictures in quite different terms: "Sex pix—should move more towards terror.... It's easy to make a funny or shocking picture based solely on the appearances or revelations of the sex organs (especially *these* organs). The difficulty is making *poignant* yet explicit imagery."

The Sex Pictures feature disembodied limbs and miscellaneous body parts—intimate and otherwise—that aren't so much functional as they are taunting. By now, prosthetic devices are nothing new to Sherman, but she is overjoyed, when embarking on this series, to learn that she can order all sorts of useful prosthetic body parts and anatomical dolls from medical catalogues—and that she can have them delivered to her studio door in obscure, official-looking packaging!

The Sex Pictures imitate hardcore pornography. Using the poses and formal conventions of porn, Sherman substitutes her clinical dummy dolls and other props for the real thing, which allows her to heighten the "bizarre factor" by offering some stunning combinations, as shown in *Untitled #250* (on page 94). Here, a grisly figure comprised of four body parts reclines on a wig-skin rug. Part one offers a wizened old head with a pursed mouth. Part two is a shieldlike torso that features a protruding belly and intensely colored nipples. Part three has skinny arms tucked in a relaxed, receptive pose. Part four is a truncated lower torso that boasts a mammoth vagina, from which protrudes a double-headed dildo—or is it a purple sausage? This image is clearly a move toward creepy terror, but offers the occasion for great laughs as well.

> *FYI:* **What is it with these dolls?**—Dolls allow Sherman to finally get herself out of the photographs, while maintaining her autonomous working process. She has tried working with models and friends, but is not comfortable in the role of giving directions and making demands. The dolls enable her to remove the focus from herself and terminate the cult of "Cindy Sherman" personality that grips so many viewers.

Sherman's checklist, which acts as a recipe for the photo, includes representations of power, death, aggression, sadness, and beauty. She mocks pornography in the Sex Pictures by making it look ridiculous, and the result is that the titillatingly prurient becomes farcical and absurd.

In his 1997 *Art Market Guide,*
Richard Polsky writes that
"Sherman has performed some
sort of modern-day alchemy.
She has convinced the art mar-
ket that her photographs should
be priced like paintings." While
he is right about the pricing, the
market didn't need any convinc-
ing from Sherman to increase
prices of her work. When the
Untitled Film Stills were first
shown in the late 1970s and
early 1980s, they were priced at
$50 to $200 each (and Sherman
gave quite a few away as gifts
to friends and colleagues). By
1992, the photographs aver-
aged more than $10,000 each
on the open market. After 1996,
they regularly sold for more
than $40,000 at auction. In May
1999, *Untitled Film Still #48*
(*The Hitchhiker*) sold for a whop-
ping $200,500. Remember the
Double Self-Portrait she did with
Richard Prince in 1980 and
never intended to show? One of
its edition of ten sold in 1999
for $134,500. (*Footnote:*
Original Cindy Sherman pho-
tographs are signed on the back
by the artist.)

How to be Famous (while avoiding Fame)

Sherman is undeniably a 1980s and 1990s star, with (one expects) fascinating new projects to come in the 21st century. Young artists worship her, curators moon over her, dealers jockey for her attention, but none of this fazes her. By the mid-1990s, she enjoys a comfort-able and long-established relationship with her gallery, Metro Pictures; an enviable exhibition record; and the financial security that allows her to pursue the creative projects that she chooses. She is well known and well thought of without having to participate in the "scene," beyond simply making her own art. She grants inter-views only when she wishes to; she does not have a pub-lic-relations firm attempting to get her name in *The New York Times* every week; and she attends gallery openings and exhibits only when the art or the people involved are of interest to her. She uses her fame and money to support the art world in other ways, such as buying art by young artists or from young dealers, and by giving money and making benefit prints for nonprofit organizations. This lends support where it is most need-ed. If she avoids the limelight, it is because she does not aspire to the life of a celebrity. Work and friends matter more to her than art-world stardom.

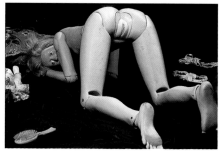

ABOVE LEFT
Untitled #244
1991

ABOVE RIGHT
Untitled #255
1992

FYI: **Artists accused of indecency**—In the early 1990s, the art world faced a diminished Wall Street, which of course meant lower prices for art. But it was also beset by the nationwide scandal involving Robert Mapplethorpe's (1946–1989) retrospective "The Perfect Moment," which opened at the Cincinnati Contemporary Arts Center and which included a number of sexually explicit images. The museum's director, Dennis Barrie, was indicted on obscenity charges (he was eventually acquitted) and the show intensified a federal debate on censorship and who should receive public arts funding. Sherman's career owes a lot to public organizations. (Recall: an NEA grant got her to New York, and her early shows and employment were with organizations that depended on grants for their survival and autonomy.) Sherman's success affords her the position of making a political statement: She purposely creates a work of art that *cannot* be shown in any museum that faces scrutiny over the issue of obscenity and censureship. Since the art market is weak at this time, most artists cannot afford to take such a risk.

99

Mix and Match

In 1994, Sherman revisits the horror images from the Fairy Tales days and pushes the envelope even further by creating a new group of ghoulishly grotesque photographs. The images are inspired as much by Surrealism (e.g., through her use of the photographic technique of double-exposure) as they are by standard references of horror. The themes of sex, violence, power, desire, and lust are all there—and, as she has done in the past, Sherman makes use of prosthetic body parts, colorful lighting, and masklike faces. The latter become important as the group of images develops, since she eliminates the body and profiles only the gruesome, vile, contorted masks.

Untitled #308, shot with multiple light exposures, features the grafting of objects onto each other to create a solitary version of the Surrealist parlor game *Exquisite Corpse*. In this game, each player would create a drawing of a part of a figure, without knowing what the others were creating. All the disparate parts were then spliced together to form a unique and intriguing whole. Sometimes the face is merely a mask; elsewhere, there appears to be a face beneath the mask.

Many viewers wonder where Cindy is in these photos. In *Untitled #317* (on page 103), you think, "She's back!" But you can't be sure: If you think she is taunting viewers who consider these to be self-portraits, then perhaps she is. In another group, which includes *Untitled #314E*, you'll notice flayed bits of faces and patches of skin, eyeballs, and decaying teeth, all flattened out

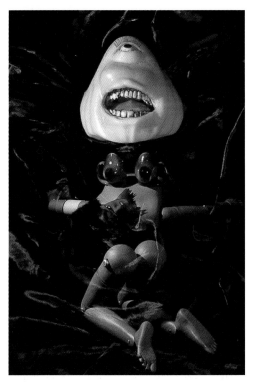

LEFT
Untitled #308
1994
69 x 47"
(156 x 106 cm)

ABOVE
Untitled #257
1992
68 x 45"
(153 x 101.25 cm)

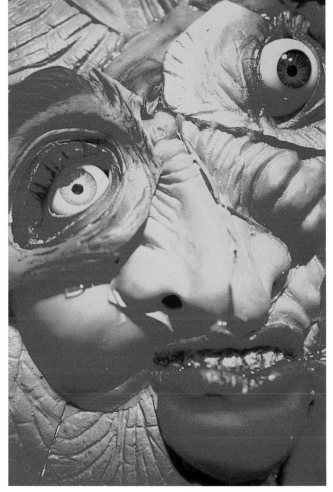

like an orange peel and permeated with blood-red tones. Anger and violence are dominant themes here, and in *Untitled #316*, it's anyone's guess what kind of strafing violence has befallen this poor creature, with her (his?) gouged and battered multi-layered face.

Going Hollywood

For years, people have suggested that the narrative nature of Sherman's work and her interest in films make her a perfect candidate to direct a movie. Working on a movie would mean that she has come full circle from her early days of producing the *Untitled Film Stills*. But she tends to dismiss this idea, since directing people and working in public settings are not her style. Things change, however, in 1995—the year in which she receives a MacArthur Foundation genius grant, which is the closest you can get to an official acknowledgment of intellectual and artistic sainthood. A fully funded movie project comes along to which she can't say no. The producers of the film require only that Sherman make a horror movie, which would have been her natural choice anyway. "The horror movie idea was perfect. I thought, if it sucks, it fits right into the genre."

She signs on to the project, ultimately called *Office Killer*, and the producers promise to hire only people familiar with her work, so that, as a first-time director, her vision is respected.

The shooting is torture, but Sherman feels confident about the editing

TOP
Untitled #323
1996
57 $^7/_8$ x 39"
(130.16 x 87.75 cm)

BOTTOM
Untitled #317
1996
57 $^7/_8$ x 40 $^1/_4$"
(130.16 x 90.56 cm)

OPPOSITE
Untitled #299
1994
49 x 33"
(110.25 x 74.25 cm)

process, which she actually enjoys, in part because it's solitary work. The movie focuses on a bedraggled copyeditor, one Dorine Douglas (played by actress Carol Kane), who works at a failing magazine, *Constant Consumer*. She loses her office, is forced to work at home, and after accidentally killing a colleague, finds that her pent-up frustrations unleash a serial rage within her. She plots to murder her co-workers (Molly Ringwald, Jeanne Tripplehorn, and Barbara Sukowa) and to recreate the magazine offices in her basement—in the company of their corpses.

Sherman is happy with the movie, though she feels that Miramax, a division of Disney that bought the project, is "confused" by it and not enthusiastic. Released in 1997, *Office Killer* is a box-office flop—even though it is greatly admired in the art world—and in 1999 goes into video.

Sherman does not consider *Office Killer* to be part of her own body of art, since she was more of a hired gun to direct the picture.

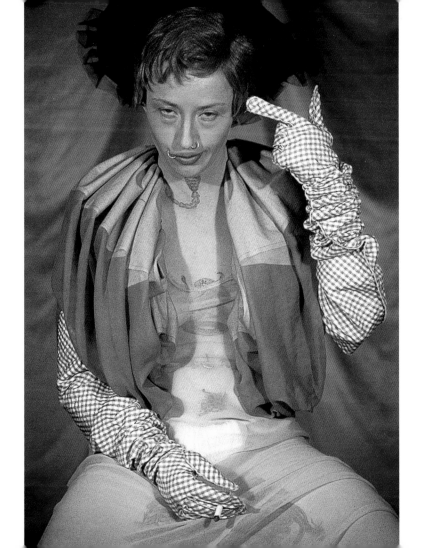

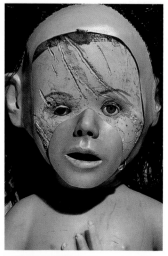

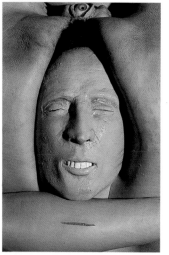

More Sex

By 1999, the list of important shows and prominent collectors continues to grow exponentially. The art world is ready for a new Sherman show and she does not disappoint. Her final work of the 20th century is a riff on the Sex Pictures. The most obvious change is that the new work is shot in black and white and has a soft-matte, muted finish that differs from the high gloss of the post–*Untitled Film Stills* prints. Whereas she had used mannequins, prostheses, and body parts in the Sex Pictures, here dolls rule the day. They still indulge in sex acts, but are decidedly more tortured. Witness the scratched face in *Untitled #335*, shown on page 112.

The characters represent the Barbie Doll, G.I. Joe, and troll variety of dolls, with the clear influence of homo-erotic artist Tom of Finland and his macho, he-man hunks (see page 109, at bottom).

As if Sherman is acting out on her objects and really enjoying it, she mutilates and manipulates the dolls in a variety of ways—slashing, burning, melting, twisting, grafting, and puncturing—that have the unexpected effect of making you laugh. Many of these creatures are displayed against fabric backdrops reminiscent of those

used for childhood photo portraits at Sears. In *Untitled #343* (on page 109), Barbie gets what's been coming to her since Sherman's childhood. Somehow, in her bruised and damaged state, the fashionable little miss has never been more captivating.

The dolls also get to play together. Take a look at *Untitled #338* (on page 109), which presents two figures: a recumbent, decapitated baby doll with a glazed look; a bald, miniature he-man doll in a sweet little jumper who squats over the larger doll. A giant penis is inserted into the image, but *whose* penis is it? The decapitated figure appears too young for such a huge penis, while the other figure's body is proportionately too small. The result? The penis is a being unto itself. And what, by the way, is that bald guy with the thick legs trying to do? He's an aggressive, persistent little guy, sure to get what he wants. But what does he want?

What does it all mean?

In the end, it is impossible to define what makes some works of art more important than others, or what leads the public to embrace them. But with Cindy Sherman, it is possible to identify the features that testify to her art's singular significance within the body of modern art. Sherman has succeeded almost single-handedly in leading artists in their use of photography as a primary art form, and has thus changed the history and future of photography, as well as the attitude of what constitutes art. For this reason, many consider her to be *the* seminal contemporary artist using photographs.

OPPOSITE TOP
Untitled #316
1995
48 x 32"
(108 x 72 cm)

OPPOSITE BOTTOM
Untitled #315
1995
Cibachrome
60 x 40"
(135 x 90 cm)

Before Sherman and her peers began coopting media images to make their art, it was less common for collectors to own photographs, and photographs were not included in the regular collections of museums. Photographic work was a specialty confined to an isolated area of critical focus, with its own rules and history.

Sound Byte:

"The new work is very violent. I'm amused by it because so much anger comes out of me, and it pleases me to see it being acted out."

—CINDY SHERMAN, 1999

OPPOSITE TOP
Untitled #338
1999
38 ¹/₂ x 25 ¹/₂"
(86.63 x 57.38 cm)

OPPOSITE MIDDLE
Untitled #343
1999
38 ¹/₂ x 25 ¹/₂"
(86.63 x 57.38 cm)

OPPOSITE BOTTOM
Untitled #340
1999
32 ¹/₂ x 21 ¹/₂"
(73.13 x 48.38 cm)

During the first generation of feminist artists, when women became acutely aware of various disadvantages and inequities that needed to be questioned, Sherman became the foremost role model internationally for other women artists in breaking new ground and in addressing the essential issue of the position of women in society. She achieved this, in part, through the young-girl stereotype of dressing up and using makeup—a childhood form of playacting, and a theatrical convention of transformation and falsification.

Sherman arrived with an unquestionably accomplished work at a very young age. In fact, *The Lumberjack*—one of her first works in photography (while not her most distinguished)—is still relevant to the ideas and ability of the more mature work. It arrived at a seminal moment

in the shifting of art ideas, when it was accepted that art no longer needed to be confined to painting, drawing, or sculpture—that art was in the realm of ideas and might be communicated in a variety of forms. Sherman and her generation of post-Modernists seized the point that all forms of art were available for their use (e.g., video, sound, film, performance, writing, and pre-used/appropriated imagery). The "borrowable" ideas, content, and images came from popular media, current pop culture, perceived attitudes (both psychological and political), and aspects of earlier art, design, and architecture. In other words, it was possible to be "original" by quoting the production or forms of other artists, past and present. Sherman became the foremost and possibly purest example of artists working instinctively within this post-Modernist model. In a natural and not self-conscious or theoretical way, she used the pertinent information available to her to communicate in a medium and form—photography—that she knew would constitute the perfect vehicle.

In the early 1980s, in an almost unheard-of consensus, the art professionals (artists, museum curators, art writers, and art critics) were almost uniformly positive in their support for Cindy Sherman. Newspaper and magazine critics were anxious to write favorably about her work. Serious and academic art theorists used her work to explicate post-Modernism, structuralism, deconstructionism, and radical feminism, even though Sherman herself did not actively subscribe to any of these theories in particular.

From 1976 to 2000, Sherman had 68 solo shows, not including the dozens of subsequent venues to which many of these shows traveled. Within an art world that became increasingly glamorized and hyped, Sherman remained modest and adamantly un-self-promotional. She served as an example to other artists by remaining focused on the work and not being distracted by her own growing popularity or by the newly glamorous and financially rewarding potential of the art world. In a sure-footed, concentrated approach to her art, she insisted on changing and on evolving. This steady evolution added to the ever-growing respect people had for her.

A common pitfall for artists who make a popular debut and who have a run of serious attention is their inability to sustain a high level of creativity and productivity as well as resist the pull of being repetitious, or of being satisfied with small changes rather than successfully evolving new concepts and presentations. Success requires the courage to change and not be inhibited by the expectations of others or by the public's reception to different types of work. It demands a steadiness regarding the possibility of failure in a highly subjective, unstable, and unpredictable line of work.

Sherman is one of the only successful artists who is also universally admired and who is rarely resented or the subject of a backlash. While no artists can expect to remain as immediately relevant to new developments and concerns over the long haul, Sherman has come as close to doing this as any other artist. Each new series of work is received as if it were the newest statement to come along in art, and not merely the further activity of an established artist.

Sound Byte:
"If anything, I'd rather make the work seem politically incorrect.... Anyway, I had wanted to explore a violent, misogynistic direction, à la de Sade and the boys; instead everything seems too 'loaded' about sex/violence."

—CINDY SHERMAN, notebook entry, 1994

An enduring Voice

The extraordinary (and not yet complete) body of Sherman's arresting work is on the minds of many young artists—photographers, filmmakers, and painters too—who have been influenced by everything from the *Untitled Film Stills* to the Centerfolds to the Sex Pictures. So profoundly has she reoriented our thinking about cultural icons, notions of beauty, the role of women in society, and human nature as we *think* we know it, that we no longer regard photography as an art form that captures "reality" or

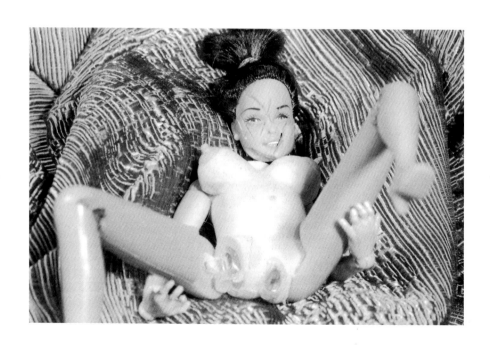

Untitled #335
1999
21 $\frac{1}{2}$ x 32 $\frac{1}{2}$"
(48.38 x 73.13 cm)

objective truth. With the interplay of illusion and reality, her art taunts us and dares us to look beyond our own limitations, all the while stirring our most guarded fears and provoking such unthinkable emotions as pleasure in the spectacle of gore and violence. Certainly photography is a two-dimensional medium, but the genius of Cindy Sherman is that if you cut her photographs, they are sure to bleed.

Cindy Sherman

BY CATHERINE MORRIS

THE WONDERLAND PRESS

Harry N. Abrams, Inc., Publishers

THE WONDERLAND PRESS

The Essential™ is a trademark
of The Wonderland Press, New York
The Essential™ series has been created by The Wonderland Press

Series Producer: John Campbell
Series Editor: Julia Moore
Series Design: The Wonderland Press

Library of Congress Catalog Card Number: 99-73515
ISBN 0-7407-0287-4 (Andrews McMeel)
ISBN 0-8109-5808-2 (Harry N. Abrams, Inc.)
Copyright © 1999 The Wonderland Press
All works of Cindy Sherman ©1999 by Cindy Sherman
All images courtesy of Cindy Sherman and Metro Pictures. All original
color photographs are reproduced in color here, and all original black-and-white
photographs are reproduced in black and white here

Published in 1999 by Harry N. Abrams, Incorporated, New York
All rights reserved. No part of the contents of this book may
be reproduced without the written permission of the publisher

ON THE END PAGES: *The Lumberjack (Scale Relationship Series),* 37 black and white
photograph cutouts mounted on board. 9 $\frac{1}{2}$ x 24" (212.80 x 54 cm)

The Wonderland Press is grateful to Jeff Gauntt and Samantha Christie
of Metro Pictures for their assistance and support

Printed in Hong Kong

Harry N. Abrams, Inc.
100 Fifth Avenue
New York, NY 10011
www.abramsbooks.com

Oxford
Infant Atlas

Editorial Adviser
Dr Patrick Wiegand

OXFORD
UNIVERSITY PRESS

Great Clarendon Street, Oxford OX2 6DP
© Oxford University Press 2005
First published 2005
© Maps copyright Oxford University Press
ISBN 0 19 832154 6 (hardback)
ISBN 0 19 832168 6 (paperback)
1 3 5 7 9 10 8 6 4 2
Printed in Singapore

Acknowledgements

Illustrations: Bob Chapman (views of the Earth); Tessa Eccles (globes, maps);
Oxford Illustrators (flags); Carleton Watts (space backgrounds).

Photographs: Mike Dudley (globe with permission of N.E.S. Arnold);
National Remote Sensing Centre (British Isles mosaic).

Contents

The British Isles

The United Kingdom (UK)

Index 32

This is the Earth in space.

The Earth is round, like a ball.

There is land and sea.

A globe

A globe is a model of the Earth.

Views of the Earth

Each view of the Earth is different.

The world

Arctic Circle

Tropic of Cancer

Equator

Tropic of Capricorn

Antarctic Circle

This is a map of the world.

Key land sea

The world

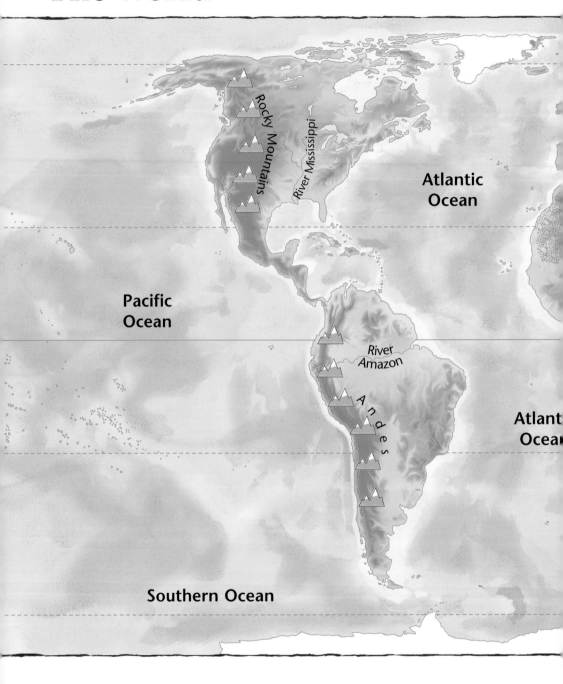

Rocky Mountains

River Mississippi

Atlantic Ocean

Pacific Ocean

River Amazon

Andes

Atlant Ocea

Southern Ocean

There are rivers, mountains, and deserts.

Arctic Ocean

Himalayas

River Nile

Pacific
Ocean

Indian
Ocean

Southern Ocean

Key rivers mountains deserts

15

The world

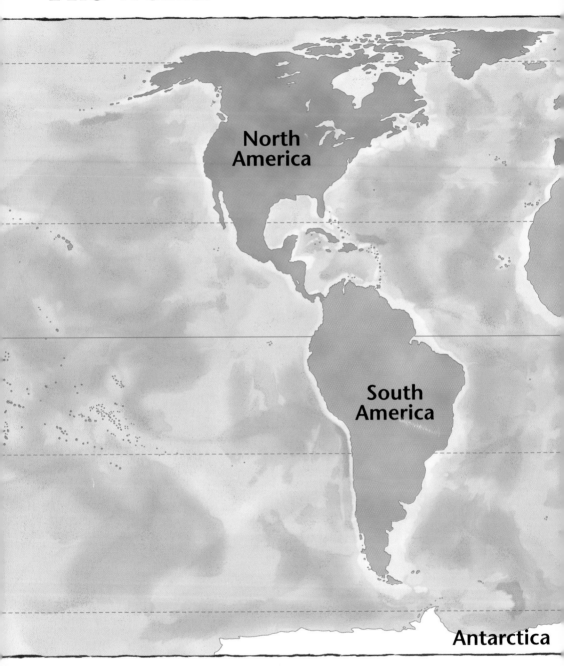

North
America

South
America

Antarctica

There are seven continents.

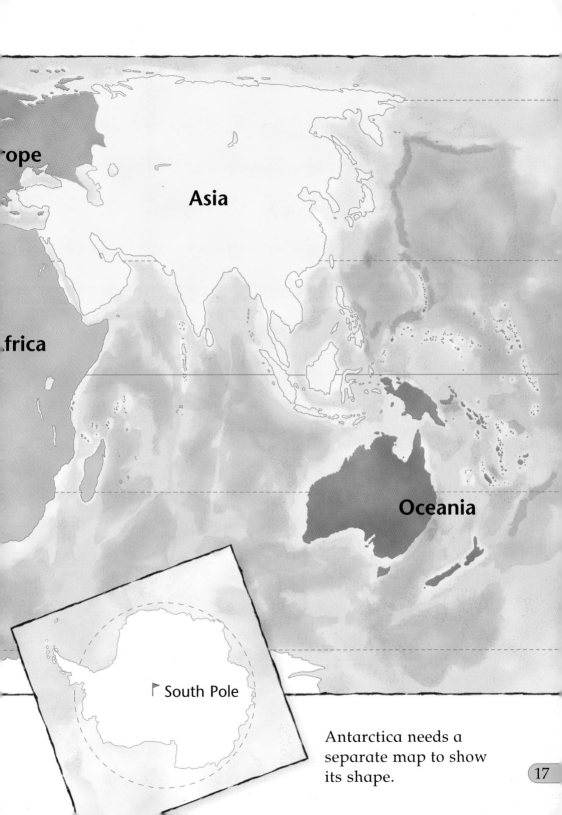

rope

Asia

.frica

Oceania

South Pole

Antarctica needs a
separate map to show
its shape.

The world

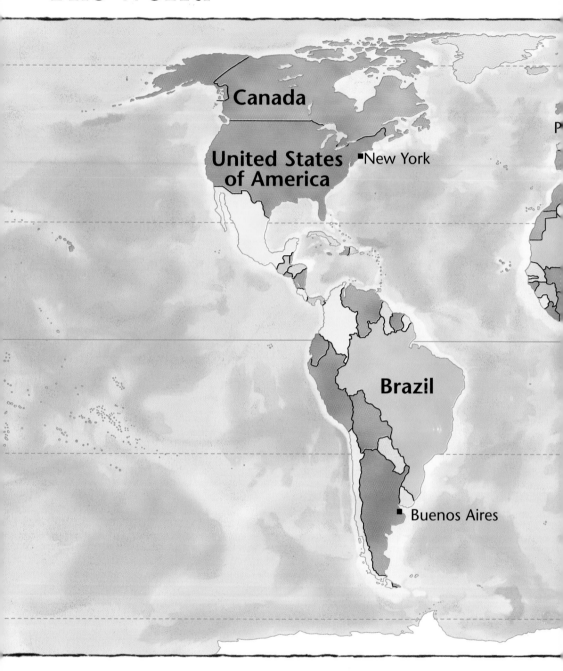

Canada

United States of America ▪New York

Brazil

▪ Buenos Aires

There are many countries and cities.

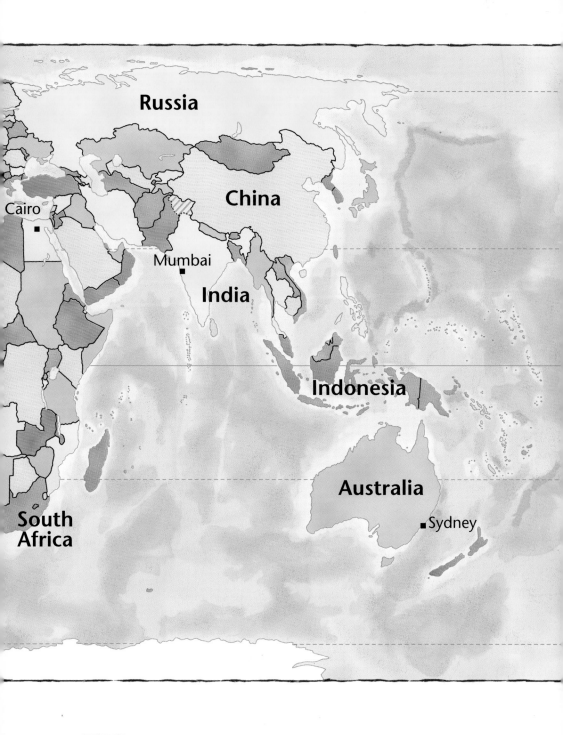

Russia

China

Cairo ■

Mumbai ■

India

Indonesia

Australia

■ Sydney

**South
Africa**

Key Colours show countries, ■ some big cities
Some are named on the map.

Europe

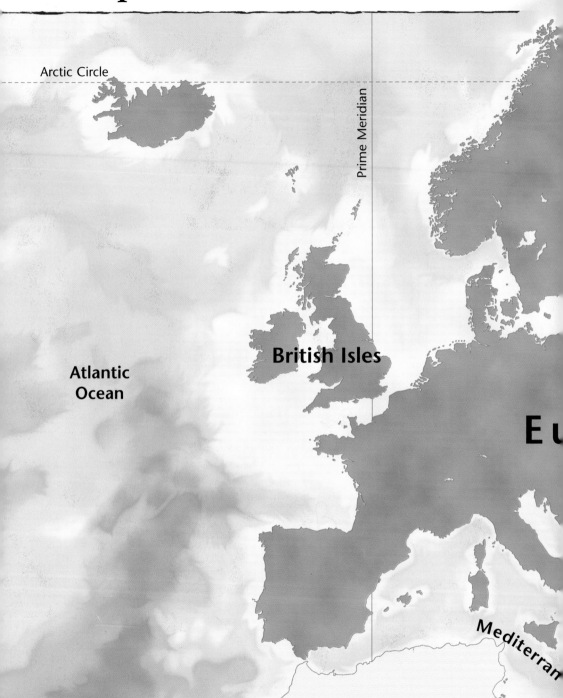

Arctic Circle

Prime Meridian

British Isles

Atlantic
Ocean

E u

Mediterran

Europe is the smallest continent.

p e

Key land sea

Europe

North
Sea

Atlantic
Ocean

River Rhine

Alps

Mediterrar

There are rivers and mountains.

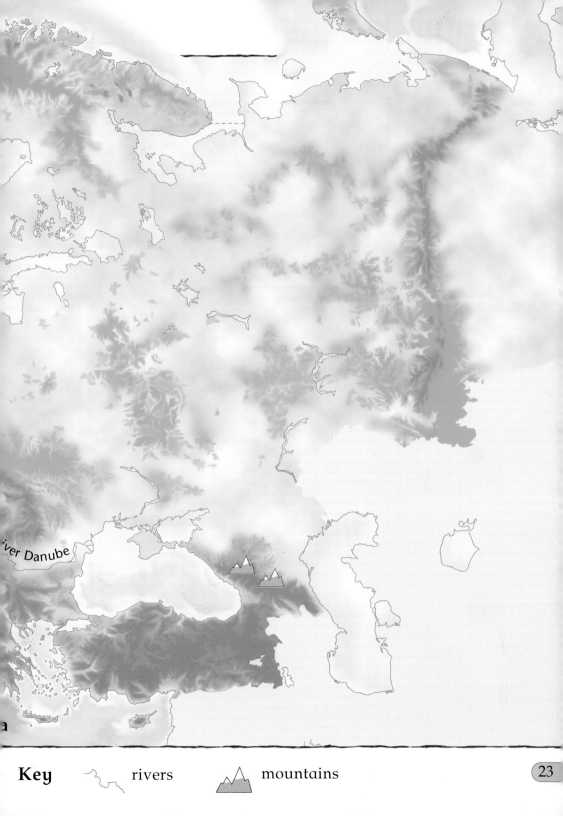

River Danube

Key rivers mountains

Europe

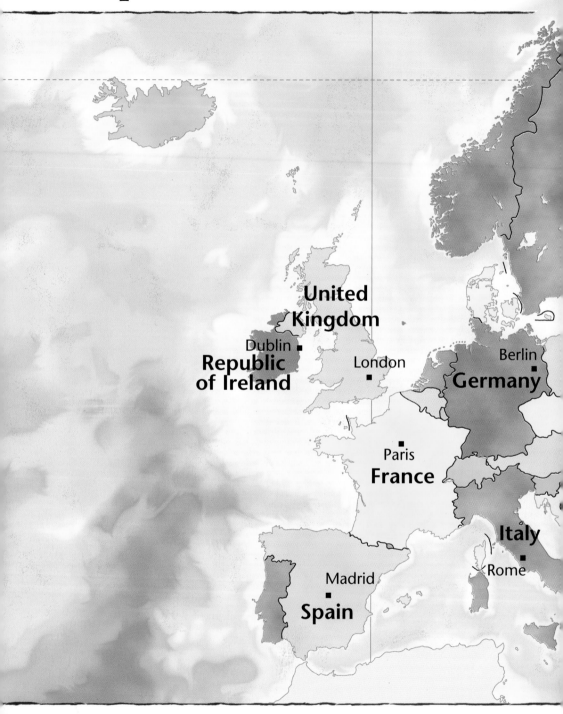

United
Kingdom

Dublin

London

Berlin

Republic
of Ireland

Germany

Paris

France

Italy

Rome

Madrid

Spain

There are many countries and cities.

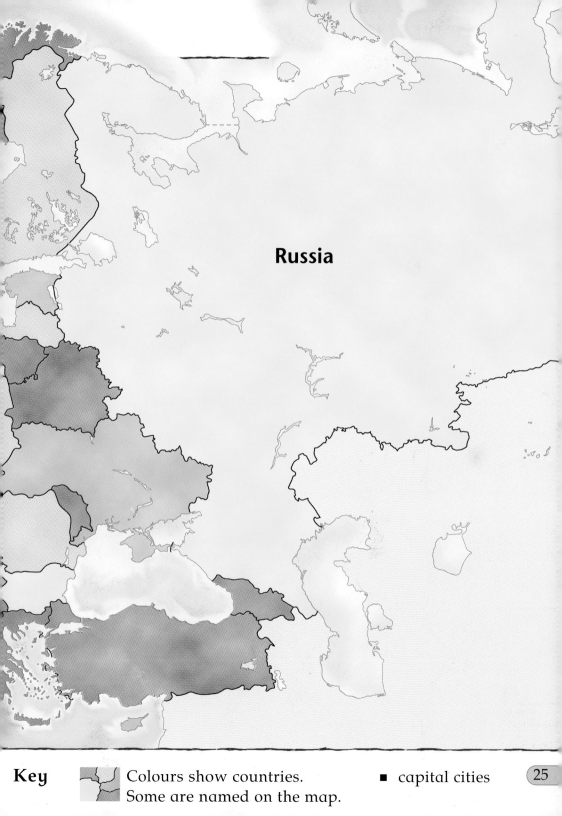

Russia

Key Colours show countries. ■ capital cities
Some are named on the map.

The British Isles

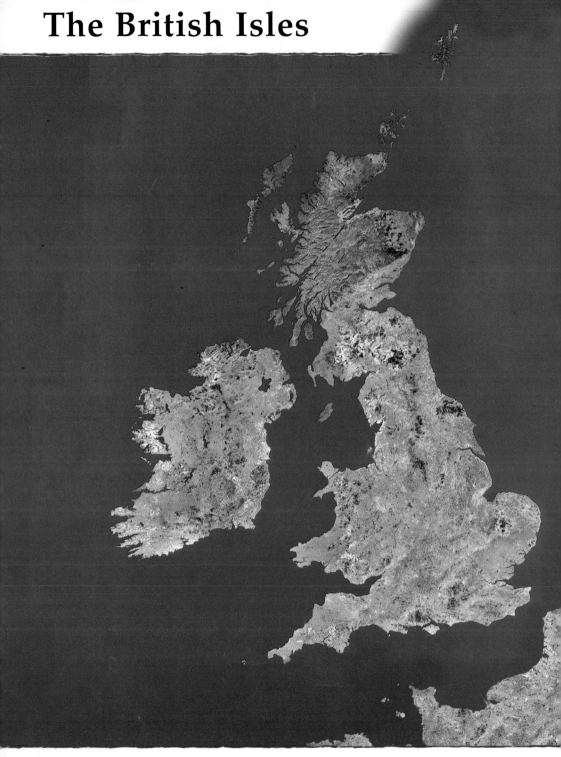

A picture from a satellite in space.

The British Isles

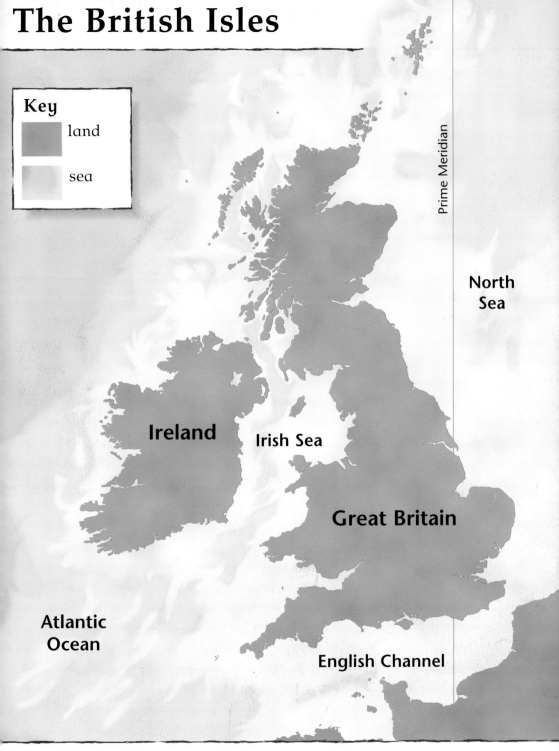

Key
land
sea

Prime Meridian

North Sea

Ireland

Irish Sea

Great Britain

Atlantic Ocean

English Channel

There are two large islands.

The British Isles

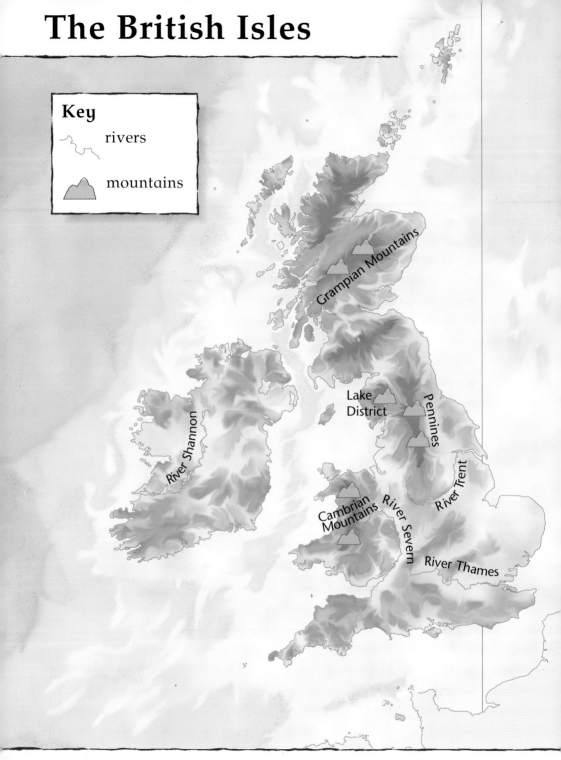

Key
~ rivers
⛰ mountains

Grampian Mountains

Lake District

Pennines

River Shannon

Cambrian Mountains

River Severn

River Trent

River Thames

There are rivers and mountains.

The British Isles

United Kingdom

Republic of Ireland

Dublin

**Republic
of Ireland**

**United
Kingdom**

London

There are two countries.

The United Kingdom

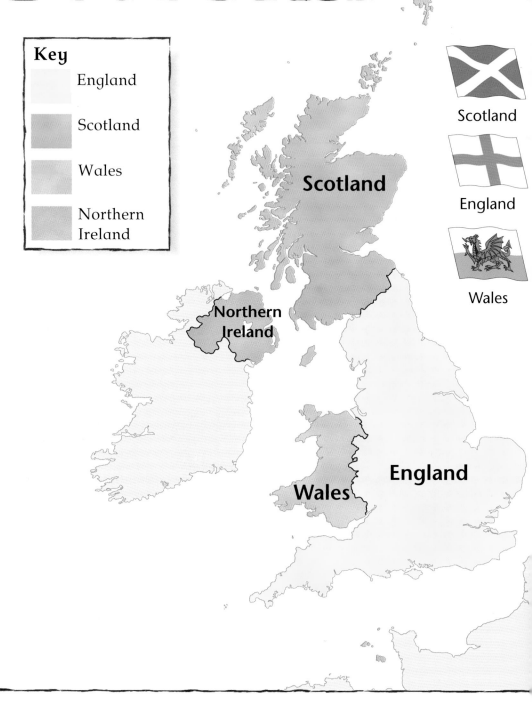

Key

England

Scotland

Wales

Northern
Ireland

Scotland

England

Wales

Northern
Ireland

England

Wales

Scotland

England

Wales

The United Kingdom has four parts.

The United Kingdom

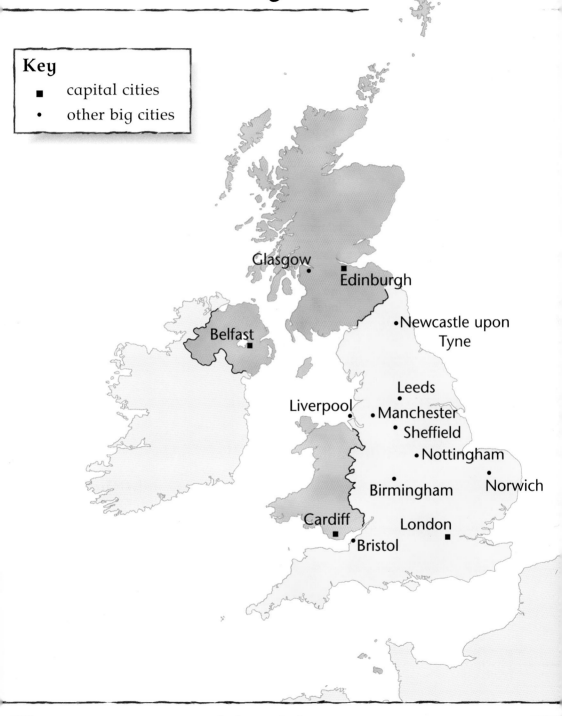

Key
- ■ capital cities
- • other big cities

Glasgow
Edinburgh
Belfast
•Newcastle upon Tyne
Leeds
Liverpool
•Manchester
Sheffield
•Nottingham
Norwich
Birmingham
Cardiff
London
•Bristol

There are many big cities.

Index

name of place

London 24, 29, 31

the pages where you will find it

32 A list of place names in this atlas.